# THE
# ENDURING
# ART OF
# JAPAN

# THE
# ENDURING
# ART OF
# JAPAN

## LANGDON WARNER

**GROVE PRESS**
*New York*

Published by Grove Press
a division of Wheatland Corporation
841 Broadway
New York, N.Y. 10003

First Evergreen Edition 1958
New Evergreen Edition 1988
ISBN: 0-8021-3132-8
Library of Congress Catalog Card Number: 58-5966

Manufactured in the United States of America
10 9 8 7 6 5 4 3 2 1

TO
LORRAINE
D'OREMIEULX WARNER

# PREFACE

STUDY OF THE FINE ARTS ILLUMINATES THE history of a race with a peculiarly significant glow and history in its turn provides the light by which art can be viewed. Perhaps, even with so few photographs and such a brief text as a small book allows, one may contrive to suggest a binocular vision of the past. Details must be scrutinized but they necessarily appear only after the scene has been set up. No two persons will agree on what are indeed the essentials for an effective summary glance. But since the course of years has so largely obliterated details, it may be that what now remains is limited to those things that are significant. For this reason alone I am encouraged to hope that, by and large, the view I take may suggest enough to make a beginning for others.

Obviously the Westerner, even one of our rare scholars of original Japanese sources, must miss many of the most telling overtones of Japanese history. While it is full of glorious fights and admirable loyalty and self-sacrificing women and all the stuff of romance, the mere sound of the name of a Japanese hero or heroine cannot thrill us like those of King Arthur or the Black Prince, the Cid or Mary Queen of Scots. But a child immersed in the folklore and hero tales of Japan will carry over to his study of serious history enough of the nostalgia and the gusto of romance to gild the very letters of those records where the great names are written down. Study of the fine arts or of history alone can never supply this strange evocative power.

Except for the necessary omission of many of the illustrations and all extemporary comments on them these chapters are printed with no significant changes from the form in which they were delivered before the Lowell Institute of Boston in 1950 and the Honolulu Academy of Arts in 1951. The chapter on Shinto appeared in the *Art Bulletin* for December 1948.

Their very formlessness shows that these pages were not intended for history nor so presumptuous a thing as a series of essays. What seemed proper enough when profusely illustrated by lantern slides hardly makes a book. Five out of the nine chapters dwell on shifts and changes that seem by their abruptness to emphasize what was always in my mind, the enduring tendencies of Japan, disappearing to crop up again in some fresh but recognizable fashion, always leaving one sure that they have been there before in some other mood — elegant or angry, gay or somber. Always the history graphically reflected in the art and always the art lit by the facts of history. These platitudes are not confined to the story of Japanese culture alone and the pity of it is that book prose presents them as still flatter than they really are.

I should like to thank Sir George Sansom and Professor Serge Elisséeff for their kindness in looking at the manuscript before publication.

L. W.

May 1952

# CONTENTS

# ILLUSTRATIONS

# THE
# ENDURING
# ART OF
# JAPAN

# ONE

## EARLY BUDDHISM

IT WAS MY GOOD LUCK TO SPEND SOME YEARS, at different times, working in Japan with the happy companionship of native scholars who were unbelievably generous to the stranger. They supplied me with a store of factual information and of sensitive, enlightened comment without which there could have been no comprehension.

And this was not quite all. There remains, after these years of pleasant delving, the feeling that I know something of what those paintings and statues were "about," and this in a very special and, to me, trustworthy sense. Wars and activities in America that have intervened serve to emphasize, rather than to dim, certain convictions and values, and to shift the emphasis from factual details, on which they were undeniably based, to other, sometimes more illuminating aspects that I wish to dwell on here.

I had the good fortune, during one full year and parts of several more, to walk in the seventh and eighth centuries in Japan; going from temple to temple along the streets of the ancient capital of Nara by day and by night, stopping work on the temple treasures to gossip with the abbot's gardener or to drink tea with his master. Gardener and abbot, like the temple precincts they trod, had been demonstrably there since the seventh century. And so, instead of exercising one's fallible imagination in trying to bridge thirteen centuries and recreate the Hōryūji or the Tōdaiji or Yakushiji monastery where I sat, the more rewarding method was to abandon so doubtful a process and, quite simply, to exist in the ambient air for deep weeks at a time. Gradually it came to pass that there was no rupture of the eighth-century thread when it came time to board the little steam train, for its twenty-min-

ute trip to my inn, nor need to dodge the troops of Japanese trippers who clustered there.

The space within which I moved was that of those ancient times, and why was not the time manifestly that of the space? Though I was ignorant of Einstein, time and space included one another. Twelve hundred years ago Shōtoku Taishi himself had taken no longer to walk from his Golden Hall to the great statue in the Yumedono than I took to cover that distance along his very path, seeing the same things as I went. Was I able to occupy the same space he had filled and not to share something of his times?

Over and over again the validity of living within the Nara period, and a century back of it, was brought home to me without shock or surprise. Once I had the luck to unearth from a muniment chest a fragment of a gilt bronze crown and unhesitatingly to walk across and fit it on the brow of the statue where it had belonged. The jagged edges met with precision, and nail sank in nail hole, corresponding to a nicety. More than a dozen times, details of iconography, which had never been explained to me and I had never known to be in question, were triumphantly settled on fresh evidence by the scholars, and I wondered idly when the correct information had come to me.

This was very far from being the inspired knowledge of the mystic, and it seems to me, as I look back on the period of my immersion, to be only what one saw while swimming under water, all quite naturally to be reëxamined by the man above when he hauled it up to his boat. Of course profounder scholarship was a thing to envy, since the chances of error in vision during immersion are very great. And yet it seemed worth while to practice what little skill I had for groping in the twilight, and occasions were numerous when I was unalterably convinced of what may be called the "correctness" of it all. Factual information, dredged from the bottom and brought to the surface to dry, forms the basis for ideas which become the very stuff of scholarship.

Obviously, I can represent to you only partially and brokenly the truth as the Japanese native scholars must see it.

But there is something to be said for the point of view of an outsider, if he is a sympathetic one. This I claim to be, and I shall make no attempt to persuade you of my own views or load you down with foreign names and dates and facts. The task I've set myself is far more difficult. It is the task of laying before you conclusions that have been arrived at after years spent on the early labor of accumulating information from the Japanese. For this reason, during this chapter, I shall confine myself to the eighth-century craftsmen. There is no better way to emphasize the aesthetics of my subject which, though not my primary interest, is usually the first thing to attract attention. I am engrossed in discovering what values lie, for contemporary Americans, in a noble foreign tradition, comparable with yet very different from our own. For I am convinced that there can be no progress for us, no improvement, no originality, without deliberate study of the stream of the spirit through the entire human race. This particular Japanese stream is all the more obviously enduring and undeniably a stream for the fact that there are in it conflicting directions and shifts in the speed of the current.

I had looked forward to dwelling on the broad flood of Chinese culture, into which the Japanese stepped hesitatingly at first in the sixth century, but swimming strongly by the eighth. Perhaps never in all history were people so conscious of what they lacked, materially and spiritually, so avid to receive it, or so capable to make use of it, as were the Japanese in the middle of the sixth century when Buddhism came to them out of China by way of Korea. One sees them simple, even primitive, anchored off the Asia coast, tantalizingly almost out of reach of their Far Eastern heritage in China, which was unquestionably the most advanced culture of the contemporary world.

A short hundred years later Buddhism, with its arts and crafts, was in full flood in Japan. At last Chinese literature, the treasures of Confucianism, Buddhism, and Taoism, already developed during the wise centuries in the alembics of India and China, were eagerly seized. A great bulk of poetry and metaphysics and literature of the imagination came with

them. An incomparably rich material civilization, with its superior techniques and skills, was carried on the crest of the same wave.

To shift the metaphor, the T'ang dynasty of China was hanging like a brilliant brocaded background, against which we must look at Japan and its capital city of Nara to watch the eighth century, while the Japanese were at work weaving their own brocade on patterns similar but not the same.

Since it is our purpose to comprehend the Japanese people during that century, it is of prime significance to see Nara, with its palaces and religious establishments that were springing up, and to discover what the artists and craftsmen were, before we examine what they made and how they made it. Only thus can we arrive at the conclusion that the China heritage was so broad a foundation that it was inevitable for the Japanese to develop a noble national art of their own with its own masters, its own techniques, and its own traditions.

Half a dozen paintings, half a dozen temple buildings, a meager series of liturgical paraphernalia, some few aristocratic weapons and pieces of furniture (most of them imported), and less than three hundred Buddhist statues of clay, lacquer, bronze, and wood, make up the total of material objects left from eighth-century Japan (see Figs. 1–17). Not a single ordinary dress of the period, not a peasant's hut with its scanty fittings is left. And yet folk art is indispensable if we would know the genius of a people. For it is certain that neither precious materials nor embellishment add much to our knowledge of the craftsman's accomplishment. Frequently these serve actually to obliterate evidence of his more direct instinctive impulse and of his traditional methods.

By the eighth century, when our period begins, the character and temper of the race was already formed: a close people and a simple one, regardful of their self-respect and that of their neighbors. Among the lower classes, they were often merry when not oppressed, and were given to dancing at harvest and when planting was done; workers with sensitive fingers and an innate sense of pattern; a people with single

aims and a single language, that developed but did not change in its essential character. All about them were the little Shinto gods of field and fen and crossroad and of hearth and mattock. Presently, alongside these, there appeared the principle figures which are my subject, the gods of Indian Buddhism, brought all the way across Central Asia and China and down the Korean peninsula.

During the century of building, Nara was a hive of craftsmen. In the temple compounds mat sheds covered the workmen, busy with construction or with forge or loom or carver's bench, and the doors of huts stood open to catch the sultry breeze. In winter there were no tight frosts, but the world was dank and chill. Outside, workers clustered over braziers or by fires of chips raked from the timber yard.

Nature suggests the materials used by the artist and the limitations that cramp him. Thus, the volcanic islands yield little stone for building and next to none for sculpture, but hard and soft wood grow there abundantly. Artists' pigments are to be found in the minerals, and a full dyer's palette in flowers, barks, lichens, and roots. Clay for the modelers and the potters can be found under the shingle of any river beach. Copper, gold, and iron are mined, and lacquer trees grow there.

What, then, was the outward look of the capital city of Nara, and what were the craftman's surroundings in that short eighth century that bulks so big in Japanese history? The town of Nara was laid out like a grid as was Ch'ang-an, the contemporary capital of the T'ang dynasty in China. In Nara streets were broader than they are today, for on one or two of the main avenues three bullcarts could go abreast. But they were often sloughs, and the man afoot chose to walk under dripping eaves or to scrape against a mud wall or a quickset hedge rather than plow down the middle.

For lack of draft animals, workers bore their own burdens on carrying poles on their shoulders. No wheeled vehicles were seen, except when the aristocracy passed on two-wheeled bullcarts, hooded and curtained like prairie schooners. These whined and groaned on wooden axles, a sound that has

become part of the trite furniture of the classical poet and is reproduced with archaeological accuracy, even today, when an Emperor is borne with antique ceremony to his tomb. But the huge balks of building timber, on their way to the temples and palaces under construction, were pulled on log rollers by bulls or by long lines of men on the ropes.

On the slopes of the hills, four miles apart to east and west in Nara city, were great monasteries set in their parks, and one could see their pagodas and groves from the rice fields and from the city streets. Midway between these temples lay the palace buildings, recently tiled in place of the old thatch, and with corner posts painted red. They were walled about, however, with rammed clay walls topped by tiles, so that the humble never saw the courtyards or the gardens.

Except in winter, the city stank with sewage, for Nara plain is hot and flat, but the odor of it could probably not be compared with the stench of the close European town of that day. The Japanese were, even then, ceremonially clean in their persons, which was emphatically not true of Europeans.

Once clear of Nara, the tracks narrowed to footpaths, unless one chose a road recently widened and mended for the passage of nobility in bullcarts. On it were unending streams of burden carriers fetching produce to town. But the line must scatter when a cavalier came by with his mounted men and his men afoot. He took for himself the beaten track, and other wayfarers must plunge into the mud of the bordering paddy fields or take a beating.

The messenger from the court to the provinces, carrying letters to some distant governor, was a knight riding a high wooden saddle with immense scoops for stirrups. He went in silk and fine hemp cloth, tan colored in summer, for the road, but in his painted boxes, carried on shoulder poles by the escort, was plate armor of lacquered leather with iron fitments and a store of food for the journey and lacquered trays and bowls to serve it. He would find no inns and must put up at the houses of such rural nobles as lived along

his route and, best of all, at temples when he found them. Failing either of these, the headman of a village was warned in advance by runner, and, when the knight reached the end of his day's stage, the farmhouse would be garnished and the peasant host and family moved out to sleep with the neighbors.

No fine foods or luxuries could be got at such places, but there was hot water, and fodder could be requisitioned for the beasts. Tea was a rarity occasionally imported and not yet grown in Japan. Rice and barley or millet could usually be supplied, but the knight brought his own wine and flat dumpling cakes or salt bean paste. He and his followers often had fresh fish, but could be sure of nothing more than bowls of steamed millet, flavored perhaps with morsels of salt fish.

At this time, when Buddhism was spreading among the upper classes with increasing speed, meat eating was frowned upon and hunting a sin. However, on the road, necessity knows no law. The fare was often varied by venison, wild pig, a pheasant from the villagers' snares, or an occasional duck. The further one left behind the dominant great temples of Nara and their ever-present clergy the more generally one saw meat being eaten when it could be got. The well-found traveler took with him a leash of hunting dogs and a perch of falcons, to beguile the journey and fill the pot.

Except for hilltops, shrine precincts, and the boundaries between fields, the countryside for some two or three days out of Nara was, before the middle of the eighth century, already stripped of the best timber. But if the traveler headed north, he came on the third day to forests where he had dread of wild beasts and evil spirits of the woods. As a matter of fact, there was little to harm, though wolves did come down so far when snow was deep in the north. Monkeys and deer and boar and foxes and *tanuki*, the lumbering badger, could be seen and, rarely, the small brown bear. It would be a good eight days' march northeast of Nara before one reached the aborigines' country. Even there, unless a cam-

paign was forward, there was seldom danger. If the escort
were too small, a flight of arrows might whistle out of a
thicket or a lagging porter be cut off from the rear of a
troop. But no forces the enemy could muster would stand
against the mounted knight or dared attack his spearmen.
These original Ainu tribes used poison on their arrows, but
their bows had short range compared to the splendid eight-
foot war bow of the Japanese, with its pull of seventy pounds
and its shaft, well over a cloth-yard length, tipped with iron
and fletched with falcon.

The Ainu aborigines were by no means all unfriendly,
and, when they were, it was in the furtive way of a conquered
people. Often they were glad enough to supply the party
with the fish and game they captured so adeptly. A greater
danger came from such spirits of evil as might be abroad.
These infested the spots where man failed to observe the
proper rites or where his deliberate sin allowed them to con-
gregate.

Most feared of all were the bands of well-armed robbers
who had taken to the road. These were not aborigines, but
Japanese outcasts, often well trained and desperate. Neither
the villagers nor the local lord of the manor could always
cope with them. They were mobile and would as soon attack
the court messenger as a private traveler, provided they had a
fair chance to beat down his resistance and despoil the party.
The records of the time are crowded with rescripts, ordering
suppression of the bandits by provincial levies and sending
troops from the capital to guard the roads.

The lot of the plebeian in Nara at this time was indeed
a hard one. His simple diet was, in good years, barely enough.
He tasted little meat, especially in the city and communities
dominated by nearby monasteries; but fish from river and sea
have always been abundant in Japan. The capital, however,
was far from the coast and has always been worse supplied
with sea fish than any other considerable town. In the eighth
century, during hot weather, ocean fish were never seen
there except by the rich, who had it fetched across the hills
from Naniwa (Ōsaka). But, then as now, innumerable

varieties were salted down to serve rather as relishes for cereals than for nourishment or bulk.

Rice was never staple for the lower classes. They steamed and boiled barley and millet, or made noodles and dumplings from their flour. During the two centuries before Nara city had been established, immigrants from Korea had been settled in the villages along the coast and over the great plain. These foreigners amalgamated with the Japanese and introduced their peculiar modes of pickling and fermenting greens, which, though never adopted by the Japanese in their full odoriferous richness of putrescence, brought new savories to the islands. Beans were a common small crop in the householder's garden patch, but *tōfu*, bean curd, was as yet a staple only of the monastic diet. The admirable fermented bean sauce, now known in the west in its Chinese form of soy and made famous to us as the basis of Worcestershire sauce, was fermented by the farmer who could construct a keg to ripen it. Of cooking fat he had little or none from animals, except what could be saved from the lean wild things he occasionally trapped. But vegetable oils, laboriously expressed from rape seed and bean and nut, were used to make his rare dishes of fry and to feed the pith wick of his dim saucer lamp. He had neither sugar nor honey. Garlic was used for medicine. Millet, *awa* and *kibi*, and the two sorts of barley, made flour and porridge. Food was less highly flavored than even today, and the Buddhist prohibition against the "five flavors" was not needed in Japan as it was in India. Even tea, brought by the clergy from China, was at first drunk exclusively by them, mixed with salt and herbs as a soup, like the *hyaku sō* in the Kinano mountains of Shinano today. On the whole, in spite of the total lack of butcher's meat, the peasant's diet, dull and unvaried as it was, seems to have been fairly nourishing. The sea fish, except on the Nara plain, and the various seaweeds of which he made good use, gave him iodine. What he conspicuously lacked was the animal fats.

His cooking flame was started by a fire drill of *hinoki* wood or by a flint. Charcoal from the communal kiln was his fuel when it could be afforded. But for many it was not

procurable, and faggot gathering had already become a vital problem for the city poor, since the sacred groves were jealously guarded and the forest had receded far beyond the city limits. Cooking gear was unglazed pottery and perhaps a rare soapstone griddle or pot, such as is used today in Korea. Food was eaten off wood trenchers or out of shallow wood troughs and bowls and platted leaves.

Each family owned some sort of small pestle and mortar, but meal in larger quantities was usually ground at the communal millstone, turned by hand or by a cow, whose milk was never drunk nor her flesh eaten. Sometimes the nearest temple, as in China today, provided both threshing floor and millstone, where each family could take its turn at the grinding and leave a small portion in kind for tithes and rent.

The thatched cottages were dark in winter, earth floored and bitterly drafty. The clay stove was chimneyless; frequently all cooking was done, as in Europe, over an open pit lined with stones in the floor. In fact the whole dwelling was often a shallow pit, set round with stakes to support the rafters and thatch. Such huts were inundated during the rains and often consumed suddenly by fire. Beds were loose straw covered with a straw mat.

While courtiers and dignitaries of the church rode splashing by in splendid robes of brocade cut after the latest Chinese fashion, peasants went in breechclouts for seven months of the year, barefoot or straw sandaled. They thatched themselves, like their huts, with straw against snow or rain, and made rough capes and gowns from hemp twine or the string rolled from mulberry bark paper waterproofed with persimmon juice. The winter crowds clad in such fustian were somber enough. Their commonest dye was derived from the *tsuruba-me* tree that produced a dark brown color, so unfading that poets adopted this word to stand for unchanging love, in contrast to the more showy red that soon faded. The many priests were clad in cloth of reddish brown or dingy saffron, tinged by vegetable dyes. Only slaves seem to have worn undyed cloth, which, till white cotton became more usual, was a light tan color.

Animal hair and wool, banned by Buddhism, was totally lacking, except for the furs and the few felts brought from North China for court use. Cotton was now being grown in Kyushu but was not generally available. A wistful poem from the Manyo Shu (557–764) reflects the damp chill of the Japanese winter:

> The wadded cloak looks warm.
> I've never worn one.

Local floods, crop failures, or plagues that reduced the manpower of whole villages at a time, often left the peasant desperate. In such times of stress a community living in so hand-to-mouth a way suffered immediately. They starved to death. Only an occasional man or boy could escape to the frontiers or manage to enroll in the levies. These at least were fed and clothed by the government, though it is on record that no pay was available for the families of those up with the colors. To be tied to the land in time of famine or drought or plague was sentence of death. It is true that, in the middle of the seventh century, the good Prince Shōtoku had built several small reservoirs in the Asuka plain for impounding water against drought, and had installed granaries where stores were held against famine years. Buddhism and the prince's tender heart were to be thanked for that. But the practice was by no means general, nor was all he could do very far reaching. Government granaries existed at the capital and in the provinces, but these were nothing more than subtreasuries where taxes, paid in kind, were stored for the exclusive use of the government and carefully guarded against the poor.

So nurtured, and with such housing, the farmer or the city laborer went out to tend his field or ply his craft, while the wife and daughter tended cocoons to make the luxury silk they never flaunted. His crops and her silk were used for taxes. In such a hut they twisted the twine for nets and for their few garments; there they did their simple cooking.

The state of the laborer or peasant in the metropolitan district of Nara was much more advanced than that of his

provincial cousin. Even when he devoted himself purely to farming, his son, by reason of the nearby monasteries and the court, had opportunities to learn a craft. Thus the lad helping with the balks of timber for the Daibutsu temple, if he proved himself handy at stripping bark and squaring trunks for the sawyers, could become a carpenter. His sister, helping at the nunnery, could graduate from unreeling cocoons and from spinning to become a weaver. But in the remoter countryside the chief crafts were those of the home, and the farmer's family practiced them all. The communal charcoal kilns were used by each household in turn, and the village pestle and mortar of stone or log in the same way. Also, as was once the case in parts of New England, the loom itself seems sometimes to have been common property — though it is not clear whether in Japan this was not the silk loom exclusively. Looms for the hemp and bark-string cloth were but the simplest frames, barely a foot wide.

If the upper classes got small book learning, farmers and laborers, from whom the artists sprang, got none. Their trades were taught them as apprentices, and their spiritual training consisted in the homely virtues of hard work and thrift and in Shinto observances. Europe before the Renaissance presents much the same picture of noble arts, produced for the church and court, contemporary with a great folk art of no less intrinsic beauty and perhaps even greater vitality and significance, all made, by means of a traditional and instinctive technique, by people who could count but not calculate and draw but not write.

Lean life and oppression are, however, hardly enough to produce a race of noble artists. To explain the consistent high level of eighth-century Japanese art, we must not only examine the manner of living, but must realize the widespread patronage of the Buddhist church and the Sinified aristocracy. More important than all was the stimulus provided by troops of master craftsmen, who were coming to Nara in the train of Chinese abbots. It is proof of the imagination and the dexterity of the native farm boys and laborers' sons that,

before two generations were over, they had become masters in their own right.

Now, with the Nara period, came a more intricate system of land tenure for cultivators held close to the land. Taxes paid in kind had the important effect of creating, if not guilds, at least hereditary classes, based on a single occupation that held tight grip on the family. For if cloth or arrowheads were demanded from a householder in such quantity that he must spend months in producing them, and if his sons were restricted to the same craft, that family perforce became specialists in those goods. If such a man did not give up working the land completely, it was only when his women folk and younger boys could help with the crop.

With the spread of Buddhism and its ban on taking life and eating meat, slaughter and its attendant crafts of tanning and leatherwork were added to the list of slave labor. Partly because of the unclean nature of these crafts, but mainly, no doubt, because certain of them were introduced and best understood by the lower classes of Korean refugees and captives, a group of outcastes grew up whose traces can be detected today in the social framework.

By no means all foreigners were despised. Indeed, by the end of the seventh century, according to *Shōjiroku*, a peerage of that time, over a third of the noble families of Japan claimed Chinese or Korean descent. In fact it becomes pretty clear that in those days there were few barriers of prejudice, and a stranger was accepted in the islands at his face value. If he were a low fellow, willing to sell his soul by catering to the irreligious who ate butcher's meat, he became a butcher and an outcaste. If he were a holy man and a scholar, he became a revered teacher.

On at least four occasions during the eighth century, certain groups of artisans among whom foreigners were most frequently found (such as leatherworkers, grooms, iron-, copper-, and goldsmiths, bowyers, fletchers, spear-makers, and saddlers) were freed from their social disabilities, a proof that an increasing value was put on their products by the aristocracy and that familiar intercourse, implied by patron-

age, made it necessary to raise their status. It is worth noticing that it was often the women of these foreigners who introduced or improved the arts of dyeing, cookery, brewing, weaving, embroidery, and midwifery.

The importance of these foreign craftsmen in the history of art can hardly be emphasized enough. They were the best teachers, and their presence at the next bench to their Japanese apprentices was the greatest force in creating what was to become the truly national art of the eighth century in Japan. Obviously the young native worker, though a free man as freedom went in those days, could never look on such master craftsmen, even the few who remained slave, as socially inferior or even very different from himself. Not only did the foreigners demonstrate daily and hourly their superior methods and skill, but when all hands knocked off for the midday meal and gathered round the cook-fires of chips from the carpenter's shed, there was exchange of gossip and of experience. These foreigners knew something of Buddhism, the patron for which all were working; they were sound in its liturgy, knew the purposes of these statues, could explain the virtues of some of the prayers and charms, and even trace a few Chinese characters.

It is to these groups, with their common absorption in the job, their long working hours and short holidays in each others' company, and their not infrequent intermarriage, that we must look for the explanation of such amazing sudden fertilizing of the Japanese native genius and the burgeoning of the arts. Your modern historian of art would give more for a stroll through the bronze casters', sculptors', and lacquerers' sheds that clustered where the new temple buildings were rising, than for all the art history books in the world.

# TWO

## SHINTO, NURSE OF THE ARTS

KNOWLEDGE OF NATURAL PROCESSES IS the very basis of all the arts which transform raw materials into artifacts. Possession of the mysteries of a craft means nothing less than a power over nature gods and it creates a priest out of the man who controls it.

Students of the history of religions divide Japanese Shinto today into three: state, sectarian, and cult. We are concerned with an aspect of primitive Shinto which, in spite of its deep social significance, seems to have been neglected by historians for its traces have already been largely obliterated by a mechanized culture.

Lying deep beneath the creation myth, which has been so much studied and emphasized by reason of its translation into ritual and finally to government, was a natural and all-pervasive animism that bound together the spiritual and material life of the common people. It was based on their concept of all natural forces and laws and the observed fact that these could frequently, to a degree, be controlled by adepts.

This animism differed from similar beliefs in other parts of the world as the Japanese themselves differed. The horrors we find in Africa and the Americas and the dark practices of voodoo seem largely to have spared Japan. Emphasis seems to have been laid to an unusual degree on gratitude to the beneficent forces of nature rather than on appeasing the dreadful ones. Sin, probably the main sin, was to omit gratitude and the respect that was due. This due respect brought about an emphasis on ritual purification and resulted in a long list of defilements and their corresponding ceremonial purges.

The land and the very air of Japan was crowded with a host of presences. These, and the reverence exacted by the other *Kami*, which were spirits of the nearer generations of the family dead and, later, by the clan and imperial ancestors, made up the foundation of primitive Shinto.

With the exception of the imperial divine ancestors, Shinto gods were largely local. Province differed from province and village from village and farm from farm in the names and attributes of the *genii locarum*. There were in common of course the fertility deities and those which dwelt in storm and shine, birth and death, and in the animals of the wild.

Sansom records that before the middle of the Tempyo period, in A.D. 737, there were already more than three thousand officially recognized Shinto shrines in Japan. Add to those the shrines of every family, the recognized but unofficial spirits in cooking fire and cooking pot, the mysterious genius that presides over the process of aging going on in the household pickle jar and the yeast in beer, the matutinal salute to the sun, the festivals of harvest home and of planting, to name but a few out of thousands. Such things, in addition to the reverence exacted by one's own clan forbears and by the imperial ancestors, made up the power of the Shinto religion.

It may be significant of how satisfactory to the Japanese racial character this relatively simple animism proved to be that even nineteenth-century attempts to develop a metaphysic within the framework of Shinto have failed. Nothing comparable to Sufism, Zen, or Thomism seems ever to have been suggested. Japanese minds demanding these higher flights of intellectual or religious mysticism have found their satisfaction in the imported creed of Buddhism.

A fact lost sight of by most historians of art is that Shinto has always been the artist's way of life. Natural forces are the very subject matter for those who produce artifacts from raw material or who hunt and fish and farm. Thus Shinto taught succeeding generations of Japanese how such forces are controlled and these formulas have become embedded in Shinto liturgies. Dealing, as this body of beliefs does, with the essence of life and with the spirits inhabiting all natural

and many artificial objects, it came about that no tree could be marked for felling, no bush tapped for lacquer juice, no oven built for smelting or for pottery, and no forge fire lit without appeal to the *Kami* resident in each.

Buddhism, arriving hesitant in the sixth century and grow-ing into an irresistible force in the eighth, provided the greatest impetus Japanese art had ever known. It was the artist's munificent patron; it destroyed no native beliefs, but served merely to provide more work and higher standards for these same Shinto gods and the artists who invoked them. Buddhist temples were erected, Buddhist bronzes cast, priest robes woven, and holy pictures painted all in foreign style, but it was all done by artists who invoked native Shinto spirits of timber, fire, metal, loom, and pigment. Even the newly introduced and very welcome practice of Indian medicine brought over by Buddhism was tempered and improved by Shinto ritual cleanliness and the enforced isolation of the sick which was quite un-Indian in character. Only a Western mind will see in such double beliefs and practices an apparent contradiction or presume to imagine any inconsistencies with even the official Buddhism. In truth there were none.

Even in the dim days before the trades were separated there must have existed a basis on which specialization would become inevitable. Growing knowledge of the controls and formulas needed in dealing with a variety of natural forces implied the formation of guilds with their separate mysteries and trade secrets at an early period.

The correct (religious) way to build a house, forge a sword, or brew liquor had been, from earliest times, in Japan as elsewhere, imbued with a peculiar guarantee of success through its dependence on a divine patron who established rules and divided labor and in whose honor the chanties were sung. To be right has always, until lately, been to be religious.

Each of the trades came to have its peculiar divinity, com-parable to the patron saints of the vintners, tanners, brewers, masons, and goldsmiths in medieval Europe. And, by the eighth century, the formulas and techniques in each had long ago taken on formal patterns which gave them the character

of Shinto liturgies, a principle easily understood by any Freemason in the West today.

The elaborate and ancient craft of house and temple building in Japan serves as a perfect illustration of the way in which Shinto, in one of its important aspects, acted as did the European guilds to conserve and perpetuate the secrets of the art. It provided for the training of apprentices and established standards in a rough examination system by which they were gradually advanced to the grade of master craftsman and priest initiate. When an apprentice had reached a certain grade of manual skill he was initiated into the theory of what he did and was taught the charms and procedures necessary to insure success. It is beside the point to argue that his rhyme giving the correct pitch for a tiled roof and the different one for thatch or the mnemonic chant embodying the proper spans between pillars had better be printed in tabular form or point out that there is no god who would wish to bring down an ill-constructed roof. These people were happily illiterate. They needed aids to memory and a system for transmitting their formulas intact to their sons. Also, if no neglected god can bring down a faulty roof, *something* does. Further, it seems highly probable that skillful, conscientious housebuilding logically can be, and perhaps should be, in some way connected with a man's religion.

It was by rules of Shinto that the jobs of fellers and haulers of timber were distinguished from those of carpenters competent to build with it. Shinto chanties hoisted the roof beam into place, timed the movements of gang labor, and preserved the necessary orderly progress that marks the stages of any construction job. Failure to observe the logical stages halts the work and therefore becomes impious, an evidence of divine disapproval. The time clock, rules of the labor union, holidays, penalties, and promotions were all part of it. The carpenter's try square and plumb bob, as well as his simple yet sufficient rule-of-thumb * formulas of angles and pro-

---

* What is that very expression "rule-of-thumb," that has been embalmed in English, but a relic of times when tape measures were not always on hand and a man's digits were?

portions, have all been embedded in Shinto rhymes and pat-
ters and aids to memory that were liturgy, litany, and sound
sense.

Thirty years ago a fresh log for the repair of the huge
Daibutsuden in Nara was laid on blocks to keep it from the
damp earth and a mat shed was built above it. I was told it had
been felled already three years, three more moons must pass
before it was hewn square, more moons still before it could
be sawn and then, the planks wedged apart for air in the
pile, still another specified number of moons before they
could be pegged in place on the great building. By that time
the dryad, *ki no kami*, who writhes in agony and splits the
log would have made her escape.

It is precisely this sort of old wives' tale that competent
sociologists and folklorists should collect in order to work out
the preservative power that Shinto has had on the arts of
Japan. For here was the mother of science.

Superstitious practices connected with the maturing of
yeast in wine, beer, and bread are divine (and therefore un-
forgettable) ordinances to insure success through cleanliness
and the regulation of temperature. Forging, planting, manur-
ing and harvest, animal husbandry, cookery, medicine, navi-
gation, and hunting have in every country been among the
arts perpetuated by liturgy, song, and drama of religious
character.

The more hidden and complicated the natural processes
involved, the more necessary are the mnemonic and religious
devices to preserve correct procedure. One has but to watch
pink-coated gentlemen of England gravely preforming blood
sacrifice on the brow of a neophyte after a successful day
with the foxhounds in order to understand why Shinto has
withstood even science so long.

A talk about fisherman's luck with a Portuguese out of
Gloucester for the Banks, or with a European baker or vint-
ner on the subject of yeast, will demonstrate the persistence
in the West of animistic religion in the modern crafts.

In early times the craftsman of the greatest skill (the
master) was naturally the one on whom the duty fell to make

sacrifice and perform the purifications to insure the success of the job in hand, whether it was a building or a boat or a sword or the cure of the sick or the difficult pouring of bronze for an image or the communal rice planting in spring.

To invoke the nature gods correctly meant that the farmer must be weatherwise and the smith experienced in the precise shade of cherry red when the blade must be drawn from the forge and quenched in its bath. Further, the correct prayers and songs and ceremonial gestures must be employed. This of course was a kind of priestcraft, an ability to control the nature gods.

But the invocations and liturgies that grew up as part of the arts can by no means be dismissed as senseless mumbo-jumbo. Embedded in them was much of the necessary procedure rediscovered by the unsentimental scientist today. They were actual rules in rhyme or rhythm or tune or cadence to insure their correct transmission from master to apprentice in a shape that made them impossible to alter or forget. The fact that these formulas were not only utilitarian but associated with the god of the forge in one case, the weather in another, and the mysterious spirit of growing yeast in a third, gave them a sacred ritual character that made it "sin" to alter or forget them.

At the time when Buddhism was at its imperial height during the eighth century, superior techniques of image-making, architecture, weaving, and scores of other crafts came crowding across from China in its train. The fresh skills were eagerly absorbed by native craftsmen who made them their own and planted them in the friendly soil of Shinto. Tools never before seen were tried and found good. New formulas for bronze mirror casting, new tricks in the lacquerer's and temple builder's trades, were learned by heart and passed over to young men by means of rhymes and chants. Thus a richer litany and more elaborate liturgy grew up in the service of the craft gods and their virtue was proved by the production of more perfect and elaborate works of art than the old days had ever seen. The patron gods remained the same. Man was better informed on how to control them.

A man skilled in such formulas was not only the head of his shop or guild. He was a priest in the very act. The Shinto priesthood, recognized as such today, no longer includes these master craftsmen. But even the recognized ones are still called on to invoke the spirits of weather and crops as well as the gods who hold the welfare of the nation and of the imperial family in their power. Until a few decades ago, however, the head of the guild performed priestly offices in special robes and was, on such occasions, sacred. Even today some villages can be found where preëminence in boatbuilding or fishing implies a temporary priesthood with its accompanying social and religious distinction. Where this is preserved, sociologists and ethnologists and folklorists must search for material on which to reconstruct the primitive Shinto of eighth-century Japan.

It will be seen then that Shinto, seldom the patron of the arts, was from the very beginning both nurse and preserver.

It is neither sentimental nostalgia nor ignorant worship of the good old days which makes us see a large measure of human good in this society where the material culture was fostered by so natural a system of craftsmen-priests. Compared with the output of an industrialized society it is certain that fewer conveniences were produced but equally demonstrable that one necessity we lack today was then available. The necessity we lack is, of course, the prime requirement that a man's trade should permit and train him to grow into a complete man.

Tending our factory and assembly lines quite blocks the complete human development of potential skills of hand and mind and soul, without which one can never be called whole and wholesome. With us, however knowing and ingenious the designer of a machine may be, however adequate the foreman of the production line, few complete individuals emerge at the end of a fruitful life. Trained first to his craft and growing week by week in knowledge of a hundred natural laws, the European or Japanese medieval maker could rise to govern his small crew, lay out their work, teach youngsters the way he himself had come, and, by reason of his responsibility and

wisdom, and by virtue of his master craftsmanship, take honorable place in the community.

With us, servile mechanical science dares not admit the need to show any respect to such outworn gods as those that govern all processes, all results of making, from the strains and stresses sealed within a building or a boat to the mysterious working of yeast in liquor, or the three years' ripening of clay before it is fit for the potter's wheel and kiln. And yet there is little harm and much good in a condition that breeds reverence toward natural forces, emphasizing and preserving a manner of doing things which long experience has proved "correct."

The nonscientific and religious attitude of the Shinto craftsman is necessary for a bookless culture, so that recipes and techniques and procedures (scientific formulas) may be kept without loss down the generations in the shape of chanties and rhymes learned by rote of heart. They become all the more indelible through their double character for they are at the same time aids to memory and magic charms like our own churning chant, to "make the butter come" and the unforgettable three-four-five rule for a right angle. Their virtue is none the less when simple minds tend to see in them a magic power over nature gods. If the essence of priestcraft can be said to be human control over natural forces this is indeed the religion of the craftsman-priest and his community.

# THREE

## FUJIWARA, 794-1185

IN THE FIRST CHAPTER WE OBSERVED THE
establishment of Chinese Buddhism during the eighth century
in the capital of Nara, and something of the ideas and the
arts and crafts that came pouring across from the continent on
its generous stream.

The Japanese in the seventh century had no manner of
recording their own speech, except in Chinese characters.
They were unaccustomed to much abstract thinking or
metaphysics till they became aware, through China and
Korea, of the rich Buddhist and Confucian systems, and they
had been entirely engrossed by the imported material skills at
which they soon became so happily adept. Over two hundred
years — the seventh and eighth centuries — had been spent
in avid absorption of everything Chinese.

But the ninth century gradually becomes a different
picture and, for the first time since before the tidal wave from
China swept over the islands, we can begin to observe
Japan proper.

The capital had been moved in 794 from Nara to Heian,
the modern Kyoto, the name of which, translated, means
(most inappropriately as it turned out) Peace and Tran-
quillity. During the next centuries the native genius of the
Japanese — so totally different from that of China — came
into control. Now at last the rich flavor of her own grapes
appears in the wine of Japan.

The chance happening that brought about this funda-
mental result was when, just a hundred years after the capital
had come to Kyoto, the newly nominated ambassador to
China pointed out to the court at Kyoto that there was no
good and much evil in keeping up contact with a China

already corrupt and tottering, already beginning to split into five petty kingdoms, whose north and west and south borders were being whittled away and whose proud capital city had been sacked in the civil wars. Thus, the connection was cut and, from 894 till the twelfth century, unless piracy and the intermittent coming and going of devoted pilgrims and a few traders can be called intercourse, little fresh stimulus came over. It was not really till the beginning of the thirteenth century that new and different impetus arrived from the Chinese dynasty of Sung and the trade in ideas was resumed. But by that time the Japanese had become a very different people from the unsophisticated islanders who had formerly sought out the culture they so consciously lacked. The empire now at last stood with her feet set on her own road according to traditions already generations old. Much more was to come over from China after communications were resumed in the thirteenth century and later, but it never again piled up the weight of that first tidal wave.

The Fujiwara family, whose name is used to stand for the tenth through the twelfth centuries, controlled the government as delegates of the imperial power and they kept the regency or the dictatorship in Heian (Kyoto). The heads of the family never, of course, sat on the throne but they saw to it that their daughter became empress. Their grandsons and nephews were emperors, and the lesser branches of their family received the patronage. Often the head of the house of Fujiwara was minister of the Right or minister of the Left, sometimes he was Kwampaku — dictator. During a full three centuries they doled out the imperial privy purse, taxed the people, levied troops, banished naughty barons, and dictated the colors and number of the layers of silken cuffs to be disclosed at the sleeves of the ladies' court kimono (Fig. 31). To be a Fujiwara was to be born to preferment. To be an able Fujiwara was to wield almost untold power and wealth — but always by means of a control delegated obliquely. More often than not the real power and brains were those of a Fujiwara who stood a little above and to one side of the titular officer. An embarrassing emperor

with a mind of his own would be persuaded to shave his head and retire to a monastery in favor of an imperial baby with a strong-minded Fujiwara mother and grandfather who could transmit the will of the throne. The minority often came to an end with his forced retirement in turn to let a baby cousin or an incompetent take the throne and the regency be prolonged.

Thus the sound, ancient, Chinese Confucian doctrine of imperial power, held by a mandate from Heaven and lapsing when wisdom and virtue failed, was inoperative in Japan from the start. Short of appeal to arms, hereditary power was all that counted in Japan.

So firmly fixed has this idea of oblique control become, down through the whole Japanese nation, that even today one must often peer behind cabinet members and titular heads of big business and directors of black-market racketeering gangs to discover some unofficial head of a clan or clique who pulls the strings from his retirement.

And by the thirteenth century we have, to quote Sansom, "the astonishing spectacle of a state at the head of which stands a titular emperor whose vestigial functions are usurped by an abdicated emperor, and whose real power is nominally delegated to an hereditary military dictator but actually wielded by an hereditary advisor of that dictator."

It was while the court and the nation were under the dictatorship of the Fujiwara family that Japanese culture took on the color and delicate brocaded texture and the unity so particularly its own.

Even the Buddhism that came originally from China and India was being modified by the Japanese. Shortly after the capital was moved from Nara to Kyoto two Japanese scholars returned from prolonged studies in China and became the heads of two great monasteries — Hieizan on the hills outside the capital and Koya-San four days journey to the south. The tenets of both the new sects, Tendai and Shingon, were more or less recent importations from India to China and received fresh interpretation and elaboration on Japanese soil. Unlike the direct and comparatively simple practices of

seventh- and eighth-century Nara, both sects emphasized
esoteric doctrines of such complexity as to be hardly accessible
to any but the trained clergy themselves, and they demanded
a multiplication of elaborate, unfamiliar images and paintings
and other symbols, as well as intricate liturgies impossible
for the layman to follow without the interference of a pro-
fessional between him and his god. Thus formulas too often
took the place of honest worship, and salvation by works was
supplanted by salvation by words.

Since the original purpose of the Buddha image was
nothing less than a symbol of the Absolute, one would find
it natural that, when that ineffable idea had been subdivided
into a hundred less abstract concepts, a hundred new symbols
would be required for differing aspects which formerly had
been enclosed in a single Totality. Thus there came into
being icons to express the terrific as well as the benign aspects
of the gods, and these again subdivided to correspond with
the particular disease of the spirit or the flesh against which
they might be invoked.

There were also maplike hierarchies of greater and lesser
gods set in their ranks about some central Buddha who was
himself only one attribute of the single, pure, and all-inclusive
ONE of the ancient Buddhism. There were wall paintings
that showed whole paradises peopled with their divine in-
habitants, and Sumeru, the Mountain of the Blest, with
the sacred lake in the foreground — for all the world like
the backdrop of a stage setting.

Such intricate subdivisions of the true conception of the
Absolute, familiar also in China and in the medieval Christian
world, produced during the tenth, eleventh, and twelfth
centuries in Japan a church art of unprecedented richness,
elaboration, and delicacy.

The art of the ninth century had been as like that of
China as could well be, and certainly it was, for some time,
the aim of both patrons and artists to keep it so. But by the
beginning of the tenth century, when there was neither
opportunity nor need to assume a Chinese attitude, came the
period of the first real medieval Japan.

In common with the secular arts of the Fujiwara period, those paintings made for worship seemed aristocratic and feminine, taking on an almost fleshly beauty that possessed immediate human appeal, sentimental and individual rather than formal and all-inclusive (Fig. 19). In fact, Buddhism during these decades tends to become a matter of aesthetics rather than of faith or even of intellect. This generalization is borne out in the succeeding Kamakura period by a revolt against such priestcraft, when the immediate saving grace of Amida spread like wildfire and, at the same time, Zen contemplation renounced all icons and all formulas.

But lay painting, as the eleventh century was approached, then entered and left behind, was so purely Japanese that one is tempted to say there was nothing left in it of China. Almost suddenly, and certainly without debt to foregoing schools of painting, the Japanese were producing long horizontal scrolls of such narrative as the world had never seen. While the Chinese of those decades, and later, gave you moods of landscape and of weather charged with all they can imply for human beings who are sensitive to nature, the Japanese showed peopled narratives and fights and journeys beyond compare.

These Japanese scrolls unroll their grandeur from the end of the Fujiwara period all through Kamakura and the thirteenth century. Some show surging crowds of warriors rushing to a palace fire (Fig. 28); in others holy men wander down long and lovely landscapes on their pious quest (Fig. 27). In subject they differ from the Chinese scrolls where, if there are men about at all, we find some little gray figure of a sage hunched to regard a waterfall or four old cronies playing chess or drinking wine, gravely gathered about a stone table overlooking a cataract with mountains beyond. When the Japanese unwind their scrolls as the Chinese do to tempt you with a variety of features, they show not only different brushwork and drawing but perhaps more change of scale and shifts in distance. You leave a busy scene to reach featureless mist or barely rippled lake surface dividing the hills or flat rice fields where herons wade and wedges of wild geese hasten high above some thatched farm and threshing floor (Fig. 27).

There is in Japanese scrolls a loose, rolling twist of pattern in the line of interest that conforms to its narrow length. But, if one can generalize, perhaps the Chinese more commonly punctuate with vertical cliffs or with nearby crags and pines. The Japanese slip to one side or shift the interest from far to nearby things, a roadside shrine or, with luck, an absorbing dogfight. The main difference is the fact that the Chinese were largely interested in matters of philosophy, while the Japanese emphasized Man and what happened in the material world at a particular time.

This sort of scroll painting was in the manner called Yamato-e, the true Japanese, in distinction from the Chinese manner — all brush stroke and horizontal flow and lovely linear emptiness or crowded pushing figures in rich color.

Thus truly native Japanese masterpieces were being produced from the tenth through the thirteenth century. In our next chapter we shall come again to a recognizable Chinese cast in Japanese painting and then, after a gap, by the seventeenth century there will appear another purely native school of tremendous vigor and high sense of emphasized pattern, not only in painting, but in the important art of lacquer and all embellishment of metal and textiles and pottery.

The new capital, later called Kyoto, was the culmination and the very type of the culture in that period when the Fujiwara family were Shoguns. And today there clings about the name a delicate savor of elegance that is entirely charming and languidly effete. It had been laid out, like Nara before it, in the form of a grid some three miles on a side, with broad avenues crossed by narrow lanes where water from the river ran in channels beside the streets as it does today. This formal arrangement determined the shape of the lots that were given the aristocracy in their quarter on the north and east. And these plots in turn, watered by channels that entered all the estates from the north, determined the classical form of the Japanese urban garden which, from this period on, became a major expression of Japanese art and by no means the haphazard affair of individual experimenters we know in the west. Great artists used this garden tradition not only to

produce a delight to the owner but, as we use painting, to symbolize the deepest religious and philosophical truths in a language understood by all cultivated persons. The ground plan of the houses was made in U-shape, fitted about one end of the estate and controlled by the water and the garden. The brook issued from between the posts on which the house rested and ran crookedly out of the U to gather in a pond where usually was a bridge and an artificial mound beyond. Thus an architecture of peculiar charm grew up that, for all the changing fashions, keeps today traces of the Fujiwara culture in twelfth-century Kyoto.

In such surroundings, beside the waterfalls and the strangely shaped rocks hauled in from the hills, was developed the unique medieval culture of Japan. There men and women capped verses from the Chinese lyrics Li Po and Po Chu-i had sung in the imperial court by the Yellow River. There they illuminated the holy books of an imported Indian religion with delicate drawings and webs of beaten gold leaf, in a manner quite unknown to the Indians or the Chinese; and there they played the game of floating wine cups down the meandering rills, with a forfeit due from the gallant or the lady whose craft foundered on the way.

Two centuries after the Fujiwara period began — say 980 — the native Japanese phonetic writing, which had been developed not long before, began to supplant the Chinese written characters for common use, especially in those fields where China had supplied little or nothing — the offhand lighthearted verses, the nostalgic ones, the diaries and love stories. It was a relief no longer to be cramming polysyllabic Japanese speech into the terse one-character, one-idea, one-syllable framework of Chinese which had come over already musty with foreign classical overtones and strict rules of usage. These new forms of literature that were peculiarly Japanese were best done by the ladies, who became more dexterous than the men, perhaps because they never had to dull their wits as men did by imitating the Chinese classics.

Whatever the reason, the eleventh and twelfth centuries were markedly feminine in literature and fashions of a

hundred different sorts. Men aped women with rouge and ribbons and in a most amazing folderol of lipstick mannerisms which seem to have been thought uncommonly fetching in their amorous intrigues.

Cut off from all new Chinese stimulus, the aristocracy of Kyoto developed in a somewhat sickly atmosphere of refinement almost beyond our power to imagine. Read the diaries of the court ladies, with their fashionably chosen colors showing at cuff and throat, see the contemporary paintings (Fig. 31) of them flirting with languishing youths, who slipped their perfumed lyrics beneath the screen and played the bamboo flute to the caged linnets by the moonlit pool. The court of King Louis of France was never more delightfully decadent or so utterly given over to the pursuit of butterflies. It is worth reminding one's self that these were the days when Harold's uncouth thanes were being harried by William the Conqueror newly landed in England.

Here was artifice rather than art, and it was inevitable that the emphasis should be laid only on the aesthetics of it all and on the titillation and gratification of the sense of taste. The heyday of Fujiwara refinement was an aristocratic culture of literature rather than life, so much so that "the terms of Indian metaphysics became a kind of fashionable jargon, Buddhist rites a spectacle, Chinese poetry an intellectual game . . . religion became an art and art a religion." Certainly what most occupied the thoughts of those courtiers were ceremonies, costumes, elegant pastimes like verse-making, and even love-making conducted according to rules.

During a bitter century and a half of civil wars before the end of Fujiwara control in 1185, the Shoguns and dictators of that name were forced to close their eyes to unseemly rows among their snarling cubs in the eastern provinces of Japan. These were the cadet houses founded by younger sons of the Fujiwaras and of the imperial house for whom no place could be found in Kyoto and who had been rusticated to take over new lands and guard their frontiers. Quit of the enervating mists at the capital and free from palace intrigue, they bred boys with a stake in the land and a lust

for border wars. Rough, squabbling, and turbulent, in another century they tore through the cobweb bureaucracy that surrounded Kyoto and, later, set themselves up in the seat of the Fujiwara Regent himself, and became the ancestors of still later Shogunates — Taira, Minamoto, Hōjō, Ashikaga, Tokugawa — each in its own turn succumbing to the ingrained Japanese habit of delegating power, till in turn each was hauled out of its sinecure by the very men who served it.

But this decay at the center was no sudden process, for the Fujiwaras had skillfully guarded themselves by parceling out tax-free manors and court titles among the lesser houses, wedging the fief of a trusted baron between turbulent neighbors, backing the territorial claims of one house against another, keeping their own fences mended and using all the dodges of those who divide in order to rule. As the provincial Daimyo built up their private armies they were more and more often called in to aid Kyoto and the home provinces, where the corrupt and poverty-stricken government was month by month less able to cope with constant rebellions. The household guard would strike for its pay and Taira troops be summoned. Gangs of monks would pour down from Mt. Hiei, four miles outside town, and make some demand, reasonable or unreasonable, and the Minamoto troops from the east would be called to the rescue. The great monasteries — Hieizan, Kōya, ancient arrogant Tōdaiji, and the others — avid for more tax-free lands, supported gangs of paid ruffians to terrorize the citizens and blackmail the government. These were no small disorderly groups, but often as many as three thousand with armor beneath their cassocks. Sometimes (it seems hardly fair) they carried in their midst the palanquin enclosing the sacred image of the god — impious to resist. And again the Taira or Minamoto must send troops to Kyoto. There was one memorable occasion when irresistible forces of nature were invoked and troopers were not needed. The Imperial Guard had broken into the compound of the High Treasurer, storming for their back pay. That Fujiwara official lived up to his family tradition in diplomacy by first calming them with a long harangue of promises and then courteously

inviting them to help themselves from the tubs of wine that were brought in. But in ten minutes the courtyard was empty and the gates slammed behind them. Each was concerned with his own inner economy. The wine contained a strong emetic.

There is a passage from the novel of Genji, written by the Lady Murasaki at the Kyoto court in about the year 1100, which describes young courtiers at the aristocratic game of football; it has been lovingly illustrated in brilliant color by a hundred contemporary and later artists (Fig. 24). Arthur Waley's translation expresses with devastating appropriateness the rudeness of these precious youths to the cherry blossoms.

> Neither the hour nor the weather could have been bettered, for it was the late afternoon and there was not a breath of wind. Even Kobai abandoned himself with such excitement to the game that Genji said, "Look at our Privy Counsellor! He has quite forgotten all his dignities. Well, I see no harm in a man shouting and leaping about, whatever his rank may be, provided he is quite young. Look at that fellow's posture now. You must admit it would suit a man of my years very ill." Yugiri soon induced Kashiwagi to join in the game, and as, against a background of flowering trees, these two sped hither and thither in the evening sunlight, the rough, noisy game took on an unwonted gentleness and grace. This no doubt was in part due to the character of the players; but also to the scene about them. For all around were clumps of flowering bushes and trees, every blossom now open to its full. Kashiwagi had not been in the game for more than a few moments when it became apparent, from the way in which he gave even the most casual kick to the ball, that there was no one to compare with him. Not only was he an extremely handsome man, but he took great pains with his appearance and always moved with a certain rather cautious dignity and deliberation. The cherry tree was quite near the steps of the verandah from which Genji and Nyosan were watching the game, and it was strange to see how the players, their eye on the ball, did not seem to give a thought to those lovely flowers even when they were standing right under them. By this time the costumes of the players were considerably disordered, and even the most dignified amongst them had a ribbon flying or a hat-string undone. . . Kashiwagi said "we seem to have brought down most of the cherry blossoms. The poet who begged the Spring wind not to come where orchards were in bloom would have been shocked by our wantonness." *

\* Waley, *Blue Trousers* (Boston: Houghton Mifflin, 1928), chap. vi, "Wakana."

Among the meager hundred series of scrolls left from early and medieval Japan one set of thirty-three preserved at the Itsukushima Shrine is not only the most sumptuous but the best documented. It was dedicated in 1164 and 1166 by Kiyomori, the head of the powerful Taira clan, and some of the volumes were written and illustrated by the ladies of his household. The text is in powdered gold and silver pigments, written on dyed papers; the outsides are embellished not only with decorative designs in color but with carved or pierced gold bronze and set at the scroll ends with crystal in gold bronze fitments, no two alike.

Hardly another monument exists which so adequately expresses that delicate and lavish twelfth-century culture as the originals of the Itsukushima scrolls. They are all precisely as one would expect after reading of that courtly culture: the holy text in gold and the illuminations made for the delight of an aesthetic aristocracy. Not only are there pictures of court ladies and extremely ladylike paradises, or lotus pools spangled with specks of cut gold leaf and silver, but an occasional herdsman or peasants fetched in as to the Trianon gardens, for contrast. This was about two centuries before the lovely Book of Hours was made in France for the Duc de Berry and enlivened with similar homely scenes rendered in the style of paradise.

By far the most important architectural monument and relic of court life that remains after all the destruction in the Japanese civil wars is the Phoenix Hall, the Hōwōdō, of the Byōdōin monastery at Uji less than twenty miles from Kyoto. It was built in the middle of the eleventh century by the Regent Yorimichi under whom Fujiwara wealth and dominion was at a splendid pinnacle immediately before the decline. It was both religious establishment and pleasure palace and here the Regent invited the Emperor his son-in-law from Kyoto to enjoy the gardens and the river. Even today it has not lost the air of an imperial villa although the mother-of-pearl is largely stripped from the lacquered pillars of the chapel, the embossed bronze has lost its gold leaf, the wall paintings are all but obliterated, and the neglected gardens

reduced to a fraction of their former spread. Like the phoenix, from which the building got its name and whose images stand on its gable tops, it spreads low, slender wings at the rim of the lotus pond.

Such buildings with long galleried wings and delicate belvederes at their tips are shown, down to every detail, in the ninth- and tenth-century Buddhist wall paintings in Chinese grottoes. Those are the very Mansions of Happiness where Bodhisattvas walk along the galleries and peacocks strut on the pleasance below. They might be the architects' renderings for the Hōwōdō, where the old statesman Yorimichi, who had constructed it all, walked with his daughter the Empress. No doubt there were such buildings actually constructed in China according to the specifications of divine architects. But not one is left there. The Byōdōin alone remains, and one must go to Japan to study this form of the architecture of the T'ang dynasty.

# FOUR

## KAMAKURA, 1185-1392

IN 1185 THE GREAT YORITOMO FOUNDED Kamakura city as an armed camp by the sea three hundred miles from the imperial capital at Kyoto. By setting up headquarters in this fishing village he escaped the debilitating miasma of court intrigue, and before he died he had succeeded in shifting the whole weight of empire off the shoulders of the ancient loose-jointed bureaucracy onto a compact feudalism based on the house laws of his own Minamoto family. These laws had been evolved by former clan chiefs and developed with an eye to preserving their provincial fiefs and consolidating them against their neighbors.

During these years while the Kamakura Shogunate was engaged in welding Japanese feudalism, the arts in Europe, together with man's attitude toward man and his increasing curiosity about himself and his relations with nature, were being fast awakened by a profound stirring. Without attempting to weigh the significance of so random a catalogue, notice that Yoritomo's life span and that of the Shogunate he founded (1147–1333) covered seven of the eight crusades, the building of Notre Dame, Chartres, Amiens, Reims, Canterbury, Lincoln, and Salisbury, and the founding of the University of Paris as well as the collegiate systems of Oxford and Cambridge. Thomas Aquinas had, in the words of an historian, "reconciled reason and religion, completed the integration of classical learning with Christian theology and remains to this day the basis of all Catholic theological teaching." Roger Bacon, Dante, Cimabue, and Marco Polo were alive, "Aucassin and Nicolette," "The Romance of the Rose," and the Arthurian romances were written, Magna Carta had been forced on King John at Runnymede, and the jury system

and Glanville's treatise on the common law were beginning to show their incalculable effects. One can make an equally good case for or against civilization during the times of the Kamakura Shogunate by pointing out that the Mongols overran eastern Europe in 1240 or that "Sumer is icumen in," one of the earliest known examples of polyphonic music, was probably composed in the same part of the century.

We shall have no such dramatic transition again in Japanese history as the shift from twelfth-century delicacy and aestheticism to the virile, boisterous period of Kamakura from the end of the twelfth through the fourteenth century. But this was by no means as abrupt as such a summary might suggest. The impotent court circles at Kyoto were for a long time still the arbiters of taste and were indeed all that remained of the old culture. But the warriors of Kamakura were not to be denied. They had the wealth, and patronage was in their hands. They had small use for women poets or the men who aped them. Nor did the new sorts of Buddhism so much call for images of the languishing deities of former generations. Even religious paintings and statues became lifelike and robust like the new times.

Perhaps the most obvious shift in ideas, and hence in art, came during the first twenty-five years or less when Japan was becoming for the first time feudal.

Power, though won decisively for the moment, was still in danger and from Kamakura Yoritomo could keep a careful eye on his family holdings, which were mainly in that eastern region. At the same time, as occasion rose, he could add to their fiefs at the expense of the other clans. For the time was not yet when even his growing Minamoto family had such great estates as the old Fujiwaras and their allies.

There was obvious need to evolve a tight system of graded responsibility descending from Yoritomo, the head of the house, to his meanest vassal. All through the country where barons of other names and loyalties watched their chance to spring, they must be bribed, threatened, persuaded or coaxed or married to Minamoto women till all Japan should be in the net. In baronies where he had yet no ties of blood or loy-

alty he set stewards and constables and provincial revenue officers and captains of the levy — all his own men responsible only to Kamakura.

From this time, during almost seven centuries till 1868, the imperial throne never controlled Japan in the sense that its lieutenants the Shoguns controlled it. The feudal system gradually developed such power that, even when the Emperor Meiji, toward the end of the nineteenth century, was rid of the last of the Tokugawa line of Shoguns and gathered up the reins in his own hands, much of the former government framework remained in spite of a more modern arrangement of struts and supports.

As the feudal system spread, the impotent court at Kyoto was easily coerced into giving Yoritomo the title of Barbarian Subduing Generalissimo, after he had already found it convenient to become Minister of State and Commanding General of the Guard. The throne was controlled in the immemorial Japanese fashion, so that by the middle of the thirteenth century there were, in addition to a puppet emperor on the throne, no less than five living ex-emperors who were at the beck and call of their masters the Shogunate three hundred miles off at Kamakura. The emperor was ignored, coerced, or persuaded but never denied.

The council of regency formed at Yoritomo's death, to aid his two sons who followed him, was presided over by their maternal grandfather who was able to transmit the control in his own family, the Hōjo, during more than a century. It was the familiar Japanese story of delegated power becoming hereditary, and eventually sapping the Shogunate precisely as the imperial power had been left to wither by former Shoguns.

While Kamakura was the actual though not the nominal capital, soldiers held the reins, since at first all problems were either military ones or must be settled with an eye to military needs. When it seemed necessary, politicians, financiers, literary men, and craftsmen were easily supplied from Kyoto where there were no longer careers to tempt them or any but the most meager emoluments. Patronage had been shifted to

this raw camp far away from the traditional seat. For all that, her background of elegance and her high standards of craft were the treasure of Japan, and were still apparent in the making of the warriors' swords, their equipment, their dwellings, and their gardens. Before or since, there never have been such swords, not even in Toledo. And it is small wonder that there grew up, around their forging and their wielding, a cult in which the knight and his weapon were one.

The Chinese, in their newly opened trade with Japan, brought home swords and other steel weapons by the shipload to the continent and in return there came to Kamakura a new style of temple architecture, copper coins, medicines, and certain ideas that fitted well with the new Japanese spirit. But China never again exerted such profound influence as that of five centuries before.

From the end of the twelfth to the end of the fourteenth century, Japanese art strikes one as being peculiarly expressive of the political and intellectual changes. This is all the more significant as we notice the former Fujiwara refinements carried on in church art and at the Kyoto court when all the rest of the Japanese world was, when not violent, at least splendidly robust (Fig. 30). The new sort of sacred paintings and sculptures were human and muscular and possessed a direct appeal (Fig. 36) which, it must be admitted, sometimes tempted one to admire the craft rather than to meditate on any abstraction. Buddhist abstractions, never comprehended by any large number of the people, were not in fashion except with the Zen contemplative sect, which scorned all image-making in its attempts to comprehend the ineffable.

The old manner of statue-making and sacred painting continued, weaker and gradually less important, for alongside it had sprung up this fresh manner and these new techniques, infused with so vital a spirit as to produce a deathless sculpture that entirely outshines the old flame (Figs. 38–43). The imperial court at Kyoto, sucked dry of direct power, of funds, and of statesmen, was, like the outworn artistic tradition, half forgotten in the zest of the new life. Let us see what the changed patronage for sacred art was, and what fresh ideas

were now clamoring for expression in every artistic medium. The thing can be got at only through some knowledge of the intellectual and emotional changes taking place in the Buddhism of that day.

The doctrines of an easy paradise were preached during the latter days of the Fujiwara epoch and already established ten years before the military government was set up in Kamakura. People were sick of the old Fujiwara Tendai and Shingon Buddhism, by which no layman could approach the god. Hōnen Shōnin, the teacher of a reformed simplicity, now struck at the very root of priestcraft and of comfortable livings. He died with the praise of Amida on his lips, convinced his prayer was enough.

> The method of final salvation that I have taught is neither a sort of meditation such as was practiced by many scholars in China and Japan in the past, nor is it a repetition of the Buddha's name by those who have studied and understood the deep meaning of it. It is nothing but the repetition of the name of Amida Buddha without a doubt of his mercy, whereby one may be born into the Land of Perfect Bliss.*

The next logical step in the same direction came when these Pure Land doctrines were taken up, to be carried further, by another monk, Shinran. He began where Hōnen left off and evolved a theory that Amida's mercy is so illimitable that one may safely forego even the difficult act of faith in pronouncing the invocation "Namu Amida Butsu"; the words alone were potent to secure rebirth in Paradise. This doctrine called Shinshū, spread like wildfire and millions practice it today. Their clergy are not celibate; they encourage morality and manage the huge endowments that have flowed in to their foundations.

A generation later, Nichiren preached in the streets of Kamakura against this loose Amidism. His formula for invoking heaven was a similar one, but it was addressed to the Lotus of the Good Law and was not calculated to secure immediate and unconditional paradise. The doctrine was, more

---

* George B. Sansom, *Japan, A Short Cultural History*, rev. ed. (New York: Appleton-Century-Crofts, 1943), p. 321.

often than not, couched in terms of bitter abuse of other
tenets and was highly charged with nationalistic and political
significance. The warriors of Kamakura, busy with construct-
ing an entirely new social framework, from tax levies to for-
eign relations, were caught by a creed that could be turned to
their immediate interest. Hōnen and Shinran had concerned
themselves with paradise, but here, in the streets, was a popu-
lar orator insisting on reforms and the punishment of rebels
against the state and church — all to the beat of drums. There
are millions of Nichiren's followers today, and it may be
that this thirteenth-century creed gives us a hint for the com-
prehension of modern Japan. But how, it may be asked, does
all this affect the styles in sculpture and painting? One more
main Kamakura Buddhist movement must be briefly sum-
marized before the background has been set to examine the
new forms in art.

Though Zen can be detected as early as the eighth cen-
tury, it began only in the Kamakura epoch to show an effect
on style in art deep-seated and obvious enough to be demon-
strated. Its philosophical content, however, may take a man's
whole thinking life to master. Dr. Daisets Suzuki has devoted
several most illuminating volumes to the subject.*

Sansom's history contains a remarkable summary of Zen
Buddhism. He writes in part:

> It is at first sight surprising that the vigorous society of Kama-
> kura should have patronized a sect usually described as con-
> templative. But Zen has other than contemplative qualities. Its
> principles were at an early date in China summed up in the
> following lines:
>
> > A special transmission outside the scriptures,
> > No dependence on the written word,
> > Direct pointing at the soul of man,
> > Seeing one's nature and attaining Buddhahood.
>
> It will be seen that on simple practical grounds, there was
> much in Zen to appeal to a soldier, particularly to one of a self-
> reliant character. Zen does not depend upon scriptures, it has no
> elaborate philosophy; it indeed is almost anti-philosophical in
> that it stresses the importance of a realization of truth which

---

* *Essays in Zen Buddhism, Introduction to Zen Buddhism*, and others, pub-
lished in Japan, in English.

comes as a vision due to introspection and not to the study of other men's words. To feudal warriors of the sternest type, the emotionalism of the Pure Land sects must have been distasteful, and they were no doubt impatient of the intellectual subtleties of the other schools. Most of them, for that matter, were not learned enough to comprehend their difficult terminology. But the sudden enlightenment, called *Satori*, at which a Zen practitioner aims, is an intimate personal experience. A Zen teacher reads no sutras, he performs no ceremonies, worships no images, and he conveys instruction to his pupil not by long sermons but by hints and indications. The pupil must examine himself, master himself and find his own place in the spiritual universe by his own efforts. So incommunicable is Zen that it has no canon.*

To recapitulate with an eye for the stimulus afforded the crafts: we have the Pure Land sects promising immediate paradise to the believer who calls on Amida; next, the Shinshū doctrines, also claiming their thousands, who were not required to make even the effort of belief if they would but repeat the verbal formula; third comes Nichiren's reform of earlier Shingon, also scorning magic apparatus — or art; finally, in Zen, is a definite refusal of all gear and impedimenta that might come between man and his identity with god.

To dwell on what would seem such artless phases of the Buddhist church during the thirteenth century is but to emphasize the unconquerable instinct for art among the Japanese, the instinct that surmounted all obstacles. Fresh and lively forms were now created to the admiration of all later times, and they came into being under the unpromising patronage described. The explanation, therefore, can not lie in the tenets of the new creeds but in the attitude of the people toward them. The new style of painting and sculpture might be shaped to conform to Pure Land Buddhism or to the teachings of Nichiren, but it is always flavored with Zen. Zen, convinced that paraphernalia such as images and even sacred books are barriers to enlightenment, made much of the direct and communicable personality of its leaders. Even though their sermons were not written down and they worked by "hints and indications," the spirit that informed these men must not be lost; hence, portraiture. For there is no danger

* Sansom, *Japan*, p. 330.

of mistaking the pictured flesh of a wrinkled old monk for pure Buddhist enlightenment, but everyone who had seen that monk would recall something of the flame of the man. Here in literal portraiture no idolatory should slip in. Further, the Buddha and the myriad Bodhisattva are of the same essence as the blade of grass or the dew that is on it, and fresh emphasis on natural forms should stand for better, more expressive symbols to evoke god than images in the old, hieratic, half-human shape.

This is clear in the painting of the day and even in the sculpture, a craft less sensitive than painting to swift impression by sketch or fleeting mood.

Among the masterpices of wood carving at this time is Kūya Shōnin, his gong hung on his breast and in his right hand the mallet to sound it (Fig. 40). In his left hand is the famous staff, tipped with stag horn, with which he belabored his heretics. The figure is a lean, old-young man with rapt visage, carved in a manner so lifelike as to startle one. It seems like a contradiction of all we have seen of Buddhist symbolism; formerly artists dared not insist on human likeness for very fear of losing divinity. Now comes scrupulous recording of the shapes that are observed, which of course are not divine. But the easy pleasure a Westerner may take in it is a trap. For here indeed is a symbol, but of a new sort. Instead of being but one step removed from the abstract Absolute, it is two steps removed. Suddenly, with a strange and rather horrid insistence (to Western eyes), out from the mouth pop a row of little images of Amida Buddha. Surely it is not necessary thus to carve in wood such symbols of the words which in themselves are but symbols. It leaves little for even a dull imagination to ponder. And yet, when we have recovered from the unaccustomed sight, that lean figure remains as vivid as any carving or painting of John the Baptist from our own High Renaissance.

It would never do to be too ingenious in one's attempts to explain what seems to be an influx of realism, during the Kamakura period, into sacred art. But there can be no doubt that it was parallel, in large degree, to the common-sense atti-

tude of Zen Buddhism and its consequent emphasis on individual character. Once the artist's feet were set toward realism and toward portraiture it was a temptation to go farther.

And the sculptor Unkei, not content merely to sustain the tradition of three generations of sculptors before him, was as great an innovator as the warriors and philosophers who employed him. His name sounds in Japanese ears as the name of Michelangelo sounds in our own. In spite of his great fame — or because of its myth-making quality — we know little of his actual life. We come on him first, at the top of his bent, carving the astonishing figures, vigorous and distinct, that stand apart from the whole fifteen centuries of Japanese wooden sculpture (Fig. 36). It is, therefore, to be expected that Unkei, like the great artists of every age, was deeply concerned with techniques. In fact, in his case, "mere" carpentry made it possible better to achieve his ultimate beauty. Further, it was a determining factor in the new naturalism and in portraiture. He is credited with inventing an entirely new system of joinery to make his figures. Perhaps its greatest use was to set free the mind of the sculptor from the restrictions of shape imposed by log and plank and block.

In the eighth and ninth centuries the tree, even before it was felled, had suggested the tall cylindrical statue that was hidden within it; and when the statue was done it recalled the tree. Lines and channels had been scored the length of the log, more or less deeply for drapery; shoulders had been squared off and the blockhead left, still attached; arms were then added, and where the toes of a standing figure jutted out beyond the limits of a tree bole, those, too, were added. But the log had constrained the artist and limited his conception and his formal idea. Later, a technique was elaborated that proved more adaptable, but was not essentially different. Seated figures had always consisted of thick block for the lap pushed up against a vertical log which was the trunk and head. But now, in Unkei's workshop, log and slab were no longer master. To make one statue, dozens of curiously shaped smaller units, planned according to an elaborate geometry, were separately roughed out by apprentices from the

master's small patterns. Overseers assembled these unprom-
ising blocks and slabs into a hollow pyramid that would be
the statue. On this were marked the incurves to be hollowed
and the protuberances to be spared. When these were sepa-
rately carved and all the joints fitted true, the hollow pile
was again set up, and double-pronged staples of iron clamped
the blocks close. Freehanging drapery was added in long
strips of wood, tapering cleverly to nothing where cloth
should seem tight against the body.

In the making of the heads, the use of the timber end and,
later, the separate block sunk between the shoulders had
been done away with some hundred years before Unkei.
Already the practice in his father's workship was to scoop
out a thick mask and a thick occiput and to glue them together
back of the ears. But Unkei still further refined the method.
His heads were vertically divided in three; the hollow mask,
the hollow ring on the edges of which were the ears, and
lastly, the occiput. When he held the light mask, with its
roughly blocked-out features, in his hand to shape it, un-
limited new possibilities were at once obvious to the carver. It
was no longer a solid knob at the end of a prostrate post,
about which he must circle with mallet and chisel or, at best,
straddle to reach. Nor was it a fifteen-pound block at which
he must hack. The shell-like head was too delicate to take or
need the shocks of a mallet. In his very hand he turned it
about and observed where the shadows fell, or he held it at
arm's length and saw where a groove must be deeper. Half
finished, it could be set on its proper shoulders to judge the
angle, and while it was not changing shape under his knife,
it hung on the wall, for leisured study at the desired height.
Likeness to life, with this intimate handling, became his inter-
est. Portraiture was in the thing. No wonder now that the
craftsman, for sheer joy in his new ability, carved with a close
observation of life that had never before even tempted the
Buddhist image-maker. Japanese art historians make much of
the Zen contribution to portraiture. But I wonder if the im-
proved mechanics, that brought easy handling of the visage
and made the medium more sensitive, were not even more

responsible than philosophy for the change. Of course there was, however, with this quickening of humanity, a corresponding loss of the abstract symbol.

Painting, too, showed the new spirit of the times. Even religious pictures, while preserving the ancient subjects and conventions, became less formal and the deities were represented less in their hieratical severity than with a certain humanity. But of course the paintings that, above all, characterize the Kamakura period were the long horizontal scrolls never intended as aids to worship or for display in the temples, but as narratives for personal perusal and as records of history.

The narrow scroll which cannot be hung but is unrolled horizontally on the mat from the left and gathered in by the right hand, affords a fluidity quite new to the Westerner. From the twelfth to the fourteenth century this development from the illuminated scripture text reached its height. It is more like the movement of music than that of the static rectangle of the movie screen to which it has often been compared. Backgrounds change as one progresses with the moving figures in the scroll (Fig. 27), but one's own motion of unrolling perhaps adds a convincing sense of progress and one can arrest the moving figures for further examination or can look across and beyond them to relish the countryside where they walk. Actual time elapses as it does in the movie. But one instinctively pauses here and there to examine and to enjoy. Such shifts are made not only by the spacing of the subject but when the artist, by well-calculated emphasis of color and of detail or with long sloping lines, carries on or delays the eye and insensibly regulates the unrolling hand (Figs. 26, 27). One can imagine the intricate problems of composition that confront the artist at every step. As in any other art, both purpose and method of use have developed their own conventions. Human figures, for instance, are traditionally introduced as coming from the left where fresh scenes are opened out and a gateway or a wall, slanting from the upper edge to the bottom, naturally acts to delay. The earlier scrolls have little or no action and the formal Buddhist paradises are usually frontally presented in units separated by

text or landscape. Sometimes the whole text runs below the
paintings which thereby acquire more continuity. The his-
torical development from simple text to simple illustration
can be traced through every stage of its history.

To clarify the record of Japanese scroll painting one must
hark back perhaps seventy-five years before the opening of
this Kamakura period to consider the earliest examples of
lay picture scrolls in the fully developed manner. These are
the Tales of Genji, from which I have quoted in Chapter
Two (Fig. 24). One feels convinced that the tradition is cor-
rect which says that the text was read aloud, intoned with
measured cadence, for these illustrations that punctuated it
have caught the mood of brooding nostalgia. Nothing could
be more remote from the lively travel and adventure scrolls
which tend to supplant them during the thirteenth and four-
teenth centuries.

For in these gentle scenes of court life there is almost no
motion, nor is there any expression on the masklike faces
that top the mounds of brocaded robes enveloping the figures,
seated or reclining in the windless palace chambers. The
nearest approach to action in them all is the figure of the
suspicious Ochibe rising to her feet to read over the shoulder
of the prince a letter just come from his forlorn mistress.
In spite of undeniable delicacy of fine touch and of lovely
color neatly applied over chalk white above the under sketch
there is no sparkle or briskness like that in the later work.
Figures are more sparsely placed, and when erect they lean
forward. The tender mood one feels in all these Fujiwara
interiors is, in this example, more like organ music than the
fiddle. Japanese historians emphasize the widespread belief in
the imminent end of the world — "the end of the Buddhist
Law," which was foretold to occur in 1052 and which un-
doubtedly did spread a profound tinge of gloom over art and
literature and even at times over politics during these very
decades.

In Kamakura days, even when the subject was to a certain
extent sacred, it dealt not with icons but, in narrative form,
with the travels of holy men and their miracles through the

familiar Japanese countryside. The story unfolds in all its idyllic charm of wayside incidents: a cup of tea at the cottage threshold or the setting out on a misty morning to skirt the rice fields where little herons are hardly scared when one unrolls the painting. No scenes so humanly intimate as the travel scrolls on the one hand or the battle scenes so violently crowded with action on the other were ever painted by the Chinese masters. There are passages in the Travels of the Nun and in the Ippen Shōnin Eden (Fig. 27) that have little enough to do with the course of the story and everything to do with sheer poetry. If the illuminated scrolls of the previous period when Fujiwara culture was at its elegant height are lovely and poetical, that is rather the obvious poetry of Swinburne, but the battle scenes of Kamakura are Horatius at the Bridge. On the other hand, the countryside we walk through in travel scrolls and the mountain peaks where the deer look up from browsing and wild geese in their wedges fly over the travelers' heads are more moving than any passage of lyric or ballad poetry I can call to mind, except perhaps the singing, half-meaningless Hark, Hark! the Lark, or O Mistress Mine, Where Are You Roaming?

Happily the Japanese today provide us with such admirable reproductions in scroll form of these travel landscapes, especially those where the originals are in monochrome, that they can be studied in full size and with no loss of subtle gray and glistening black of their medieval ink. As for the other subjects in Kamakura scrolls we are richer still, for two great originals in their pristine brilliance can be examined in the Museum of Fine Arts in Boston: the Kibi Daijin Scroll, and The Burning of the Sanjo Palace. The first illustrates the adventures of the eighth-century ambassador Kibi Daijin from Japan to the Chinese court (Fig. 25). Action and humor keep one enthralled; we see the arrival of the embassy ship, the imprisonment of the ambassador, the tests imposed on him by his Chinese hosts where he is coached by the ghost of his predecessor in office whom the Chinese had murdered, down to the closing scene of the chess game where he is made

to drink a purge and so give back the chessman he has secretly swallowed.

Less subtle but more splendid in brilliant color and in dash of draftsmanship is The Burning of the Sanjo Palace, one of the three extant scrolls attributed to Sumiyoshi Keion of the thirteenth century (Figs. 28, 29). It is perhaps the greatest of the Kamakura warrior scrolls. Hardly anywhere else in the art of any country can be found such weight of armored chivalry, such terror and running and scurry, such an overturning of bullcarts, or such a smother of choking smoke shot through by orange flames. While the palace is being fired there is a bewilderment of active detail (Fig. 28), but at the end the crowds string out gradually thinner till the advance is held in check by a lone general reining in his plunging black stallion preceded by a single archer on foot with his arrow on the nock ready to let fly (Fig. 29).

In the Kitano Tenjin Engi scroll there is another unforgettable conflagration in the scene of the vengeance of the Thunder God on the imperial palace after the unjust banishment of Tenjin. Over the Kyoto palace roll black smoke clouds riven with scarlet lightning bolts, "scribbles of God's finger in the sky," while officials in their voluminous robes and insecurely perched hats are tumbled about abjectly below.

A mere recounting of the adventures and the travels shown in the Japanese scrolls of the eleventh through the fourteenth centuries prove them quite unlike the scrolls of China in which, as we have seen, man's activities are seldom emphasized. In Chinese paintings the eye wanders down long stretches of river landscapes or across to distant mountain ranges. Unnamed travelers are observed with their burdens but we do not know them or ask their destination. They serve their purpose by providing scale and life to the landscape. The eye wanders and observes, but we do not seem to be on the spot to associate ourselves with happenings here and now, nor does the pace shift as it does when we find ourselves joining the party of the Japanese nun searching for her brother, pausing to drink tea and gossip or to ask the road while a galling pack saddle is shifted and the mistress'

cat can be seen asleep through the open door of the inn. It may be, perhaps, that Chinese paintings are nobler for being remote from humanity, but we are engrossed in noticing how the Japanese, who owe so much to Chinese stimulus in the art of painting, developed it at this period in so vitally different a manner, putting it to such different use.

During the next period, that of the Ashikaga Shoguns, we shall see the supreme efforts of aristocratic painting in Japan bent on purely Chinese manners of rendering and on the aloof philosophic interpretation which the Chinese originators had lost two centuries before and seem never so perfectly to have recaptured. It is not my purpose to follow to its decline this particular Kamakura trait of emphasizing the narrative. For shortly after the middle of the fourteenth century the scrolls lost much of their amazing technique while their particular sort of poetry of the Japanese countryside was transmuted into a new poetry of abstract renderings of nature, done in the summary brush and ink of the China of two centuries past. This change is hardly compensated by the value of the later scrolls as records of contemporary costume and archaeological detail. For instance, the scroll of the Mongol invasion, Mōko Shūrai E Kotoba) was set down only a dozen years after the actual historical event and one can study the accouterments of both armies and the very build of the war boats. However, twenty years before the Mongol picture came a scroll of nine imperial guardsmen schooling their mounts. That seems to be one of the last thirteenth-century scrolls where one is at a loss whether to admire more the vivid and crisp technique or to be grateful for so convincing a contemporary record (Fig. 30).

Intellectually the importation of a series of Chinese Buddhist sects, gaining fresh vigor in the new soil, was contemporary with the coming of the more philosophic Zen that was to become so powerful a force and to color the following years of Japanese art. Politically the empire was knit under a feudal government controlled below the passive throne by hereditary Shoguns. In sculpture the new technique in wood gave scope for new triumphs such as the Chinese seem

never to have reached for lack of a more logical joinery, improved tools, and renewed scrutiny of anatomy. In painting, too, a fresh interest in humanity was the fashion (Figs. 32–35); a humanity that was purely native, concrete, and interested in portraying Japanese events in Japanese surroundings by a technique fundamentally different from that inherited from the continent. This was the final triumph of the scroll form and Kamakura scrolls seemed to epitomize the other changes, the purely Japanese costumes and familiar landscape and vivid native brush strokes all bound together in long compositions contrived within the narrow strip of paper which solve to the beholder's delight the insoluble problems of composition that must cohere no matter how short or long a space is rolled up or where one pauses to concentrate, for there seems no weakest link. Perhaps the greatest triumph of all is that there seems no artifice.

# FIVE

## ASHIKAGA, 1392-1568

IN THE LAST CHAPTER WE SAW THE LIFE-
blood of Japan come flowing from a fresh and healthier heart
at Kamakura. But after the Kamakura Shogunate fell and
before Yoshimitsu, the third Ashikaga Shogun, came into
control of the entire country, the land underwent more than
fifty years of bitter strife, which Japanese historians call
Nambokuchō, the period of North and South (1358–1392),
and which they sum up as consisting of wars between rival
branches of the imperial house contending for succession. As
a matter of fact, there were more than a score of interclan
wars, swinging back and forth over the land, when this or
that cluster of barons swarmed about one or the other of the
imperial claimants and used those brief, shifting loyalties to
make their own squabbles seem legitimate and their enemies
traitors.

Ancient temples, the main storehouses of works of art,
were ablaze in every province. The entire land was bitterly
impoverished, and whatever remained of the old loyalties was
repeatedly traded about as the clans bid for advantage with
one or the other imperial prince. Religious establishments
and their private armies were not content with waiting to de-
fend their lands and treasure, but scurried into the melee or
seized the chance to attack and spoil each other. If ever the
traditional chivalry of medieval Japan did present an edify-
ing spectacle, those were not the days. It was a thoroughly
degrading picture of double-dealing, betrayal, and vicious
cruelty. Works of art were wantonly destroyed and fewer
new ones were created. Perhaps some historian will arise who
can explain why, in spite of this hell's broth, the like of which
never lasted so long in Japan before or since or ever again

became quite so vile, the very name of the Ashikaga period brings before one's mind lovely paintings, a singularly discriminating connoisseurship, and the austere wisdom of the Zen Buddhist priests who were court counselors to the Shoguns and conducted the most important institutions of learning in Japan.

However, once the imperial succession had been established in 1392 in favor of the northern branch, the Ashikaga family, who had managed the campaigns in the field and been ministers of state and to whom victory over the southern house had been mainly due, found themselves reaping their reward and ruling Japan as Shoguns, like the Fujiwara and Minamoto families before them.

But even then there was no peace, nor was there to be peace. This time it was not a struggle for the imperial succession, but among the great provincial families for land and loot, and as houses were divided, there was fighting between rival heads. Many of the provincial wars were quite unrelated to the issues at the court of the Shogun or to the imperial house — mere land-grabbing among clans splitting up on questions of succession. Every man had his price, and many collected that price three or four times over as they sold out their allegiance.

The imperial house no longer mattered. The throne, as an institution, had no political significance. No emperor was important enough to be forced to abdicate his empty title, as they used to do under pressure. One was confined to the Shogun's Kyoto buildings for thirteen years, and another lay unburied for lack of funds for several months. The palace, after it was sacked and burned, was not properly rebuilt or guarded, so that commoners picnicked on the grounds, and members of the imperial family were pleased enough to sell their autographs or quotations from the classics copied in their elegant calligraphy.

The new Shogunate had returned from Kamakura to the ancient capital of Kyoto and built its palaces in the quarter of the city known as Muromachi, not far from the imperial court. This still retained its rather bloodless manner of life

developed during the past five centuries — that same culture from which the Kamakura Shoguns had fled and against which they had warned their successors. No doubt the nearby influence of the imperial court had much to do with the extreme refinement developed under the new Shogun's court a mile away. But, it must be remembered, they were heartily sick of decades of some of the bitterest civil wars ever known and of the loss of nearly every material and spiritual thing that a cultivated Japanese had loved and valued. A period of rest and of devotion to things of the spirit was long overdue.

Cultural contacts with the Ming dynasty in China had been resumed, and these were no doubt a stimulus. But such contacts did not amount to an inundation from China like the one we saw during the seventh and eighth centuries at Nara, the ancient capital, when Japan was first lifted along on the Chinese flood. There was indeed a short but intense, though not very deep-rooted, period of Chinese fashion, when the Shogun Yoshimitsu himself wore Chinese robes and rode about in a palanquin.

All this time the priestly Zen advisers were cultivating a sort of common sense along with the highest flights of metaphysics. Though historically based on the stories and sermons of the Zen patriarchs in China, the sect developed, at this period in Kyoto, a peculiar salt and flavor of its own that could be nothing but Japanese. Priests were the garden designers and the connoisseurs of painting and other objects of art collected by the court of the Shogun. They were supreme in the tea ceremony which, like the art of gardens, preserved the nostalgic traditions connected with the great names and days in China. But there is no manner of doubt that the Japanese greatly modified these two arts as they did so many others, all the while keeping loyally alive — if only for the sake of the classical overtones — the idea that the Chinese had been the unexcelled masters.

Despite savage civil wars, together with the swift decay of the ordinary loyalties and the code of the knight, the arts flourished beyond all admiration under the Ashikaga Shoguns. To endeavor to explain this extraordinary state of things is

not so profitable as to examine the works of art made under the patronage of the Shogun's court. The rather thin, if delightfully extravagant, aestheticism practiced under the Fujiwara from the tenth to the end of the twelfth century, and the subsequent rude and hearty fashions at army headquarters in Kamakura in the thirteenth and fourteenth centuries, gave place by the fifteenth century to a high serious painting entirely divorced from both previous forms. There are no longer those lovely, illuminated, sacred texts in brilliant color (Fig. 18), nor travel scrolls nor violent conflagrations and battles. Instead there comes to Japan from South Sung in China, a renaissance of philosophic and poetic ink painting of a sort which the Chinese themselves, try as they might, had never been able to recapture.

Lavish and pleasure-seeking as the court was, the things that were made for them — particularly the paintings — showed no taint of the decadence under comparable luxury so obvious two hundred years before. Nor was there to be seen any sacrifice of high, sincere, intellectual straight thinking, as the Fujiwara Shogunate, busy worshipping the merely aesthetic god of loveliness, had sacrificed it during the eleventh and twelfth centuries. Even the old games of incense-matching and verse-capping and of ceremonial tea were now presided over by a stricter taste. The contemporary Shoguns' courts made it possible and fashionable for the Japanese to collect, study, and copy Chinese paintings of the South Sung dynasty, which had come to an end two centuries before. But no mere sedulous vivisection and study of Chinese masterpieces could have produced such paintings as were made in Japan. The contemporary Chinese themselves tried without success to revive the style; so too did later Japanese, but with no remotely comparable results. Through the entire fifteenth century and the first half of the sixteenth in Japan, the painters Chōdensu, Nōami, Geiami, and Sōami, Shūbun, Sesshū, and Keishoki carry one along in a single, unbroken sweep of towering genius.

It is always said that the tenets of the Zen sect of Buddhism were responsible for this art. And certainly the austere

restraint of Zen philosophy and its metaphysics formed a large part of the warp and the woof of Ashikaga culture. But I am heretic enough to believe that these ink paintings, along with the thinking of Zen Buddhists and the restrained delight in the quiet elegance of the tea ceremony, were merely parallel evidences of fourteenth- to sixteenth-century Japanese culture. Those three, along with a dozen other cultural phenomena, bore witness to the temper of that day in Japan, but no one of them was the immediate parent of the others.

This age was not remarkable for such scrolls as those of the Kamakura period — the battle and the burning of the palace, or the droll animal caricatures, or the trials of the much-abused Kibi, ambassador to the Chinese court, or the travels of the nun through the countryside, or the magic of the flying granary. Mainly, we find ink pictures, in which the brush technique of practiced calligraphers has reached heights that same brush reached in China. It manages, with admirable economy, in a flick to show a curving surface and an edge. The soft ink is coal black, or watered down to a mist of gray (Figs. 44–52). It omits just as the eye omits in looking at a landscape, and the spectator brings to the scene his own image-making faculty that we all share, no two of us alike, the exercise of which is the highest creative delight.

Comparable with the other contemporary arts in their extreme restraint and their power to evoke an emotion they never express, is that of the drama called Nō. It was played by and for the aristocracy, and some families were so practiced in it as to become virtually hereditary professionals. Westerners have translated the obscure texts, but with what seems to be a sad loss of its real effect over the Japanese. If these plays can be said to have plots, they are usually miraculous happenings through which a few characters walk and say their lines with exaggerated deliberation to the accompaniment of a chorus which, at one side of the stage, chants and plays on shrill wind instruments and little drums. The robes worn are brocades and embroideries (Fig. 59), as sumptuous as the familiar court robes of the Chinese, but infinitely more various and interesting. One, at least, of the characters on the

stage wears a carved mask, which has the arresting effect of being a pivot for the human faces of the others. Rigid and unchanging as the wooden mask must be, the shifts of light bring changes of expression that rivet one's attention as it slowly turns about. The making of these character masks — no longer huge grotesque headpieces like those worn out-doors by the mystery players of the eighth century — was at its height in this period of Ashikaga and in the Momo-yama period which came after. The names of generations of the carvers are recorded with care, and the somewhat smoothly empty visages they carved are preserved among the treasures of the families for whom they were made. The character represented by some famous mask has often been explained to me — a mean old man, or a sorrowing widow — and, by staring at it, I have hypnotized myself into finding in its smooth vacuity all tragedy or the epitome of innocence or the experience of age. But in my case at least, this was pure auto-suggestion like that induced by the ink paintings of the Ashi-kaga masters.

The comic interludes performed between the Nō dramas are a relief to the uninitiated, for we can all readily compre-hend the mechanical difficulties of two men, falling heir to a single pair of breeches, who try to inhabit them at the same time; or of the cheating fruit dealer, selling astringent persim-mons, whom the judge sentences to eat his own wares and then to whistle. It is simple horseplay of the old, immortal, international sort.

Yoshimitsu, the third Shogun of the line and first who en-joyed periods of uneasy truce between the clan fights, was patron to the ablest poets and painters and sculptors and phi-losophers of his time. His splendid court was kept up, even after his abdication and retirement to the Golden Pavilion set in its enchanting gardens outside Kyoto. He and his circle were no doubt responsible for the half-secular tendency in literature and painting and architecture. For, as in the Euro-pean Renaissance, there was an end to the ancient tradition that all the arts were essentially handmaidens to religion. No doubt the Shogun's pleasure-loving and lavish court had much

to do with this, and the new splendor with which he was surrounded.

The Kinkakuji, the Golden Pavilion which was his garden pleasure house, was a building of the utmost refinement and deceptive simplicity (Fig. 53). True, the interior was covered with plain gold leaf, but there is no carving and no outside color. This building, and the garden in which it stands, are the very symbol and type of the highest and most significant in Japanese lay art. Short of an exhaustive study of the principles of the garden art as developed in Kyoto, together with an examination of Chinese landscape gardening traditions and the nostalgic place names used by Chinese and Japanese classical poets, one could hardly begin to do justice to it all. Familiarity with such a structure reveals, even to the uninitiate, innumerable fresh discoveries of contrived simplicity, and such subtle comprehension of scale and proportion that the thing is a source of renewed wonder and delight.

I have written it *is*, but bad news has come again from that distressful country. The Golden Pavilion burned to the ground in 1950, and we have lost the little gem of architecture which, if no other remained, would bear witness to the mastery of Japanese architectural joinery (one does not speak of carpentry in this case) and to that elusive quality called taste. So far as I know, it resembled nothing that was ever made in China, nor was there ever, in Japan or elsewhere, chapel combined with tearoom that so exquisitely expressed the garden in which it blossomed. The shingles were tiny flat slices of cedar bark laid, almost paper thin, in layers that emphasized the gentle upcurve of the eaves. The unpainted pillars and beams and struts were embellished by the weather, through five and a half slow-moving centuries, with an even, gray lichen of microscopic texture. When the paper walls were slid back there was a sense of open structure — a sort of heavenly shed. For all its delicacy it had no weakness — strong and slender. I've seen it in sun and rain and wind, and once when the sun came out after a shower and its entire roof was steaming diaphanous clouds.

Much as one would have wished to see the garden and

the lake with its islands and this perfect structure on the day when they were finally completed and the Shogun sat with flutes on his balcony, still the art of the old landscapist has gradually been transmuted into pure nature.

For, with slow and subtle fitness, trees have become big and died and been replaced, the margin of the lake has been molded by incessant small lapping waves to even greater perfection, and the linnet, scared off by workmen five centuries dead, nests again by the spring called Silver.

# SIX

## THE GREAT DECORATORS
### 1573-1750

MOMOYAMA, PEACH HILL, WHERE TAIKŌ
Hideyoshi built his castle in 1593, is the name chosen to call
up the splendors of that half century when the first of the
Great Decorator school set up their crowded workshops to
embellish the new large audience halls and long corridors
lined with landscape screens and floored with wood of honey
color. The fashion had begun some fifteen years before with
Nobunaga's castle of Adzuchi on the shores of Lake Biwa,
and, Osaka castle, begun in 1586, had been still another
stimulus which helped set the fashion for Daimyos' castles in
the provinces (Fig. 54). The Momoyama period is marked
off in histories as lasting forty-seven years from the beginning
of Nobunaga's *de facto* Shogunate until Tokugawa Ieyasu
captured Osaka castle from his rebel son and established
Tokugawa Hidetada to succeed him.

Although the Great Decorators demonstrably began with
Kano Eitoku's work on Adzuchi castle about 1578, that most
descriptive name has properly enough been extended to cover
a later and entirely different manner of decoration — the
Kōyetsu school — down through Kenzan, Kōrin's younger
brother, who died a hundred and sixty-five years later in 1743.

The three great rulers in succession whose patronage un-
doubtedly made the new fashion in art were Nobunaga, Taikō
Hideyoshi, and Ieyasu the first of the long line of Tokugawa
Shoguns. It is of the utmost interest to follow, at least in
outline, the political events which accompanied if they did
not cause the almost explosive outburst of color and broad
composition in painting under new patronage.

In 1573 Oda Nobunaga, the Captain General under the Ashikaga Shogunate, had discovered that the fifteenth Shogun was plotting his downfall. He promptly seized his master, kept him in confinement, and thus brought to a close the period of a hundred and seventy-five years during which the Ashikaga family had been the all-powerful vassals of the throne.

He was the first of the three great characters who, by extraordinary chance, succeeded one another directly and thus, in their short forty years, were able to lift Japan through a welter of fighting clans and by the end to weld it into a unified and peaceful nation. For, with the power in Nobunaga's hands, there followed during his time and that of his two successors, a period of wars and intrigue comparable to that of the twelfth century when Yoritomo had been bringing his barons to heel under the Kamakura Shogunate.

The task of unification was by no means done when Nobunaga was murdered (1582), and the second of this amazing trio, his famous lieutenant and heir to his ambitions, Toyotomi Hideyoshi, in some respects the greatest of the three, found himself in the position he had been scheming for. Hideyoshi was unique in Japanese history. Never before nor since in that close aristocratic society has a vassal risen from such low status to the highest responsibility under the throne, and probably none ever showed such amazing ability in the camp and at the council table. A servant in a village shrine, later apprenticed to a carpenter and then to a blacksmith, by sheer self-confidence and some rather ugly trickery he reached a position from which he brought the great lords and generals to their knees, or bribed them.

He made it possible to establish a peace that was to endure for two and a half centuries and, for better or worse, to stiffen the mold of Japanese culture with a new feudalism and a new sort of aristocracy made up of new names. However, this peace was not established till after Hideyoshi, his ambition still unquenched, had launched two enormous armies across the straits and up the spine of the Korean peninsula, recklessly stabbing at China. And within the year he marched them

back for sheer inability to supply their rations. When he died in 1598 he bore the highest title under the throne — TAIKŌ. He has been compared to Napoleon and to Alexander the Great, and if the room in which he fought and schemed had not been a little one, remote from the great continental impulses, the character of the man might well have changed history in Asia and in Europe.

This successor to Nobunaga was a baseborn parvenu, under whose lavish patronage Japanese art — perhaps for very boredom after centuries of the stringency of good taste — spread and burgeoned, belying its traditions with obvious relish. It rioted and boasted in gold and silver. Even the tea ceremony, originally conceived to be held by five cultivated cronies in a thatched hut, now used massive gold and silver and took place in half a dozen palaces and temples simultaneously over the city.

The third of this magnificent trio, Tokugawa Ieyasu, was no parvenu like Hideyoshi, nor even a petty lord like Nobunaga. There was still a deal of fighting to do and of intrigue to contrive before he could reach their pinnacle. But he finally topped them, for he not only completed the tasks they had begun but founded his own line, the Tokugawa Shogunate which lasted through fifteen generations of peace until, succumbing to that very peace which insidiously sapped the vitality of the Tokugawa family and of their court, the Shogunate was abolished in 1868 and the Emperor ruled direct. An irreverent Japanese cartoon sums up these three great ones by picturing Nobunaga preparing the rice paste, Hideyoshi cooking the dumpling, and Ieyasu devouring it. This is hardly fair to the last of the three who accomplished far more than merely consuming the results.

The connoisseur Shoguns of early Ashikaga days, in their slender unpainted garden pavilions had played their elegant games of incense and of capping verses, and compiled their catalogues of Chinese paintings; but they also patronized Nōami and Sesshū and Sesson. At the end of the sixteenth century, spurred by fresh opportunity and new demands, a

new generation of painters proved themselves equal to the challenge. The Kano school, without for a moment forgetting their heritage of noble brushwork, developed in the broad castle rooms and screens such a show of crimson and emerald and purple on backgrounds of gold that the big audience halls fairly sang and danced with color (Fig. 55). These were the Great Decorators. After so long a period of delicacy and subtle gray hints in Japanese painting, it is almost a relief to watch a full hundred years of sheer decorative pattern splash across Japan.

The style is a combination of two very diverse schools. This had begun to take place at the turn of the sixteenth century when Kano Motonobu married the daughter of Tosa Mitsunobu and modified the crisp Tosa outlines and the dense color of traditional Yamato painting by infusing into it something of his Kano manner which had been developed from the Chinese. It had been appropriate enough, for narrow Tosa scrolls and for the niceties of album leaves, to use small patches of opaque color set in cells of black ink. But the side walls and sixfold screens of the vast rooms in castles and temples must either forgo this tight angularity or quite fail of their decorative purpose. The intermarriage between two rival families is by no means so cogent a reason for adopting the high color of the one to combine with the broad drawing of the other as is the fresh demand for covering space and for the carrying power necessary for bigger rooms. Further, the new patronage, unlike that of the former aristocracy, was quite content to abandon all subtlety of execution as well as of significance.

Our English term Great Decorators for the artists of that day is most apt. And even if it implies mere decoration and suggests a question as to what they decorated, and if we suspect a lack of deep intellectual purpose, the term is not unfair. Their subject matter was never profound like that in the religious icons of former ages or in the philosophical landscapes by the monkish ink painters of the Ashikaga period. And yet a pair of screens by Sanraku or Eitoku (Fig. 57), standing quite alone, decorating nothing, gives one an

almost physical shock; we are not concerned with intellectual content.

At first Eitoku (1543–1590), head of the Kano family, slightly later his followers Sanraku and Sansetsu, and then, quite divorced from the Kano manner, in quick succession, crowding on each other's heels, the Great Decorators, Sōtatsu, Kōyetsu, Kōrin, and Kenzan make a procession as with torches against the sober gray mist of Japanese secular painting that lay behind. The mere fact of an enlarged scale, due to the building of fortified castles which also served as palaces, with their enormous audience halls, had much to do with the changes in painting introduced by Eitoku. Certainly there was now a demand for wall decoration and for high screens of six folds that would shine out gold in the vast dim interiors, presenting such spread and surface to tempt the painter as Japan had never known. Lining an audience chamber where three hundred knights knelt in rows before the chieftain's dais, these distant walls were big and brilliant patternlike landscapes of rich color on backgrounds of gold leaf (Figs. 55, 57, 58). Above were coffered and paneled ceilings painted with flowers, and at each crossing of rafter and beam a chiseled gilt bronze stud enriched them. Below, the floors were spread with mellow natural straw mats that gave a subdued glow to the whole interior space, unbroken by furniture, unspotted by rugs.

The peculiar patterned scenes of Eitoku were often painted with little enough detail, but in such flat shapely masses that a single glance of the eye takes in a famous bridge and its hanging willow, or zigzag plank paths that cross a blazing iris marsh, or a Chinese emperor with his ladies on the terrace engaged in the spring ceremony of waking up the plum blossoms. Summary as many of these patterns are, one finds that they are rendered by master brushes working in flat areas of powdered lapis, malachite, and the sparkling white made from powdered oyster shell. All the better if the brook is a twisting stripe of actual lapis lazuli powder and the moon is a crescent of silver leaf.

Eitoku died before his patron Taikō Hideyoshi, but not

before he and his workshop had marked an epoch in Japanese painting. His compositions at first were often Chinese in subject but remote as possible from the South Chinese landscapes and brushwork of the Ashikaga Shogun's court. Imperial hunts and pageants and palace scenes were the not very subtle things that were portrayed. To suit the new palace and castle interiors Eitoku seems deliberately to have coarsened his drawing and increased his use of gold leaf far beyond that of his predecessors and, by a process of sheer enlargement to fit mural dimensions, he arrived at a splendid mosaic of glowing color in flat shapely patches (Fig. 57). Among his technical innovations he achieved luminous color even in his water pigments by what would be called, in oils, glazing light over dark or dark over light. Venice with its rich oleaginous surfaces hardly excelled in splendor this dry, heavy, tempera treatment of somber contrasts against brilliance. Luckily, some of the greatest treasures from Kano Eitoku's workshop were removed before the ruin of the Momoyama palace and may now be seen distributed among the temples in Kyoto with the gates and pavilions for which they were painted.

In one mood, Kano Eitoku was capable of confining his splendid vigor of ink stroke within the traditional limits of Oriental hanging composition. But his pairs of sixfold screens and palace interiors in flat color and gold leaf know nothing of such patternizing slavery. Their very merit seems to be that trees are frequently cut off above the roots and below the tops and that their branches gesticulate beyond the borders (Fig. 57); his bridges neither begin nor end. But Sanraku, undoubtedly his greatest pupil, lost something of this peculiarity. He practiced a deceptive but recognizable geometry, different from that of the Occident but more concentrated than that of Eitoku, and he deliberately leads the eye around and back to its starting point. There is no suggestion that his compositions were sawed off in so artless a fashion.

The Kano painters after Eitoku never seem to have been able or to have wished to recapture his peculiarity. But this new attitude toward pattern — continuing to paint in the

air, as it were, beyond the boundaries — was a great factor with his youngers of an entirely different school, painters like Sōtatsu and Kōyetsu (1568–1637) and later, Kōrin (1661–1716). Their startling compositions, even on fans and small lacquer boxes, are often chopped off so abruptly as to seem to break all traditions of composition, east or west.

Italy was never more sumptuous nor did Flanders render with greater literal truth than Kōyetsu, Eitoku's younger contemporary. Both Sōtatsu and Kōyetsu brought to their compositions big and little, that part of the tradition of the Sung renaissance in Japan when the early Ashikaga ink painters had developed their brush with such amazing flow. To this their immediate forebears in Momoyama days had added the sumptuous colors of the native school of Tosa and spread them on what one hardly exaggerates in calling an acreage of gold leaf. Their colors were opaque, flatly laid on without detail, and the proportion of the vivid colored areas to the composition is generous and maplike. Kōrin, born ninety years after Kōyetsu, did the same thing and also painted and designed pottery and lacquer in a more summary fashion. In his albums and screens and hanging scrolls he was apt to omit all but a few most essential outlines and to render them in lighter color and between them to lay solid areas of purple and lapis and emerald.

The paintings and lacquers and robes by Kōrin and by Kōyetsu two generations before have seemed to Westerners to be the most characteristically Japanese of all Japanese schools. But these shapely patches of abrupt color and amazingly tilted compositions are unlike all previous Japanese compositions and their egregious awkward scale and abrupt grace failed to persist (Figs. 60, 61). They captured the imagination of the samurai by their boldness and novelty but failed to live on in the works of later Japanese masters. They have been, however, kept in suspended animation by hundreds of imitators and innumerable forgeries and copies. Perhaps such simplification and abbreviation by a master can be superficially suggested by second-rate artists, but if it does not express a racial instinct it fails.

One is tempted to think that this new style of patternizing, so immediately recognizable as beginning in the last quarter of the sixteenth century and fading by the middle of the eighteenth and so diametrically opposed to former manners, was a revolt from the ancient subtleties of occult balance and hidden symmetries which themselves had been developed to temper the earlier more obvious balance and which had satisfied the whole of the Far East. The ancient bilateral symmetry of Buddhist compositions had begun to break down in the Kamakura period, no doubt through Chinese influence as well as that of the long horizontal adventure scrolls of Japan, but it still persisted in temple pictures and for wall paintings although for centuries it had been avoided, as too obvious, in landscapes and other lay subjects. Symmetry, however, was always present even when occult (Fig. 61). It was the response to men's need for that order which philosophers in the West believe to be prime mover in all man-made systems and things — science, philosophy, poetry, religion, and art. Now perhaps for the first time in the Far East, this patternizing sense, which is never to be denied but is the better for being partly submerged, became even more subtly expressed by avoiding balance of the ancient expected sort, no matter how hidden and intricate. The fashion now was to break the composition off short, and at the same time to satisfy the mind's eye with hints of fulfillment that would complete the pattern and bring order beyond the borders of the picture. This was no denial of man's craving for deliberate composition in art, rather it was respectful acknowledgment on the part of the artist that you and I prefer only a hint, an arrow pointing the way.

The abruptness of this remarkable seventeenth- and eighteenth-century Kōyetsu school, so essentially different from the mellifluous work of the contemporary Kano tribe, was carried to its logical extreme by the use of unexpected and traditionally incongruous materials in shapes so seemingly naïve and even clumsy as to be quite meaningless in themselves. This was noticeable in the case of lacquer, a medium hitherto associated above all others with jewel-like delicacy

(Fig. 60). Roughly hammered areas of ignoble lead were inset within laboriously miniature gold lacquer detail; and even pearl shell, hitherto used with threadlike lines and edges, abandoned its brittle delicacy to be sawn into clumsy areas. This was all part of the seeming offhand casualness of the composition. To describe a lacquered writing box of Momoyama times is to suggest how un-Japanese as well as how un-European this new sort of unbalance became. For the flat lead stern of a punt may be more than half of the composition, and it shoves its way backwards among six rushes with a mere three formal ripples of delicate gold lacquer below; the butt of the punt pole is all that suggests a passenger, and that is of pearl.

The art historian on the trail of his logical past may discover influence back of all this, but I am persuaded that it is part of the revolt of the Great Decorators against subtlety. The country lords and their samurai who were the new patrons were barely literate and were delighted with handsome surfaces that carried no intellectual freight. It was all of it quite new in spite of certain inherited tricks of the trade which can be identified as originating in both the Tosa and the Kano schools.

Beginning with Sōtatsu, certain innovators dripped pools of other pigments on their wet colors, to spread and partly blend — showing, for instance, the variegations on a leaf beginning to bronze in the fall. They built up the curved white petals of chrysanthemums by palpable masses of gesso or they abandoned previous convention, along with nature herself, to spread their formal colors. But color as originally applied by the earlier Tosas in minute spots to make a brilliant patchwork on a scroll or the page of an album, can never have the same effect as those same opaque pigments arranged in generous areas. Nor can edges, small and distinct, be considered the true ancestors of the divisions between patches sometimes performing the function of an outline, sometimes of surface, sometimes of hard or rolling edges, and always of contrived unifying pattern.

How to square the neglect of soft ink and the abandon-

ment of subtlety with the taste of the tea master, Sen Rikyū, their mentor and undoubted arbiter of style in the Shogun's court, has always been a puzzle. For he was the master architect of quite flowerless gardens made of greenery or sometimes of raked sand alone. He selected the proper objects for sober tea ceremonies and was, to his patron the Taikō, what Sōami, the painter and connoisseur, had been to the Shogun's cultivated circle in the garden of the Golden Pavilion. Sen Rikyū formulated the strict rules of the tea ceremony — of which perhaps the most rigid was that, among gentlemen, there must be no rigidity. He insisted that the tea utensils should never be ostentatious or of costly material. When the fashion was developing for antiquities to be used in serving tea he inveighed against extreme rarity and the high cost of such things. From his teachings also comes the use of the words *sabi*, patinated, unobtrusive, reticent, as highest possible praise for an object, and *shibui* for that discriminating artistic taste which is neither for the sweet nor the sour, but rather for the gently astringent which avoids and suggests them both.

And yet, with the consent and encouragement of this very mentor Sen Rikyū, first Nobunaga and then Hideyoshi, those robustious generals, gave tea parties the like of which no one has seen before or since, and which must have broken to atoms every rule he made. Three or four old gentlemen in a thatched hut drinking the mild beverage from rough Korean peasant bowls, gave place to a ten-day picnic of four hundred indiscriminate guests of all degrees boiling their water in the gardens of Kitano Shrine or, worse still, to a score of high officials served on solid gold from the Taikō's treasure house. The rather lame excuse seemed to be that the material from which a tea service was made was of no consequence and, to the Shogun, gold was as pottery to the commoner. But that has a spurious ring to it.

The screen paintings that shone splendid in the Prince's great hall were often moved out to enclose that acre of the great garden where a picnic was held. Perhaps the legend is true that the Taikō Hideyoshi himself was borne between

double lines of them along a full eighteen resplendent miles when — baseborn stable boy as he was — he deigned to make one of his rare visits to the court of his imperial master at Kyoto. The Taikō's palace was at Peach Hill — Momoyama — and on its site today the plowman can sometimes turn up a fragment of a roof tile with the gold leaf still clinging.

When one walks near the massive temple and castle gates of the period — so simple and weighty from a distance — they flower and sparkle with rich polychrome carvings back in the deep shadow of the eaves (Fig. 56). Pillars that seem plain tree trunks, roofs that are simple tile or two feet thick with tiny cedar shingles, are seen now to enframe long horizontal shadows crowded full of animals and of foliage, tempting one to walk closer for very wonder at their elaboration of carving. But nowhere does detail obscure or belie the logic of the structure. Three generations later ornament obtrudes brazenly, obliterating what supports it. Then the Shoguns of the Tokugawa era were making their mausoleums at Nikko, for the admiration of Japanese tourists in a less sensitive generation.

There is an exuberance rife during this period of Momoyama, a readiness to take on new ventures and an eagerness for novelty. Although the new manner cannot be said to have reached such intellectual heights as the painted scrolls of Kamakura or the lovely ink landscapes of Ashikaga, it was appropriate for the new times and far more striking. Display and splendor had never been so marked in Japan before. If it was not vulgar it was because Japanese taste, now for the first time flaunting and gorgeous, retained an elegance even when restraint and understatement had lost ground.

By the last quarter of the seventeenth century there was even an increased flamboyance of rich materials and of color which has left the Genroku era (1688–1703) a name for flamboyant architecture and costume and lacquer and screen painting that satisfied the appetite of the times. It was then that Kōrin and some of his wealthy plebeian patrons, picnicking on the banks of the Kano above Kyoto, tossed their bam-

boo-sheaf dumpling wrappers down stream. A party of aristocrats lunching below caught up the leaves as they drifted past and discovered that the inside of each one had been painted with incredibly small gold lacquer designs by the master himself. Whether or not this arrogant gesture was a deliberate taunt, the sumptuary laws were called into effect and Kōrin and his friends were punished for having in their possession utensils more precious than commoners were allowed. Kōrin was later again to fall foul of the authorities when the linings of the kimono worn by his womenfolk were found to have been painted by him, every stroke of whose brush would have cost a piece of gold to buy. To celebrate a fellow artist's birthday Kōrin and his companions trundled a mammoth dumpling below the balcony where his friend sat drinking. The cake, too big to fetch indoors, was pulley-hauled up and a gap chopped through the railing to where they sat. When the dumpling was sliced open scores of tiny crabs scampered out, each with a minute gold-lacquered landscape painted on its back.

These few decades were perhaps the last when such fun was so fast and furious and yet when Japanese taste held so nice a balance against vulgarity. It was all like those delicate gold lacquer boxes embellished with a coarse patch of lead. But the humor of the times occasionally mocked itself and was too good to last.

It is characteristic of the Japanese that traditional ink painting of the Kano school should have continued to be in demand; with Kano Tanyū (1602–1674), who was appointed official painter by the Tokugawa Shogunate in his twentieth year, came a half century of leadership by an artist who, by dint of his talent and official position brought the Kano family back to its traditional place. As head of the family and court painter to the Shogunate he was in demand through the whole country. The provincial Daimyo were all creatures of the Shogun. Popular as Tanyū's Great Decorator rivals were in imperial court cricles with their traditional love of brilliant color, it was he who spread the works of the revived Kano school among the great houses. His group

studied and copied and passed judgment on the Shogun's art treasures; they studied nature till they could render her to the very life, as the family tradition demanded, and then translated her shapes and her growth into their own lovely patterns. Their drawings were used in all the arts; on sword guards, on textiles stenciled and embroidered, on lacquer and on pottery. Of course the later men became academic in time but Tanyū, the master, never saw this fall. Till his death at seventy-two he thought and he painted in luminous ink shot through with javelins of ink that was blacker still.

With the last of the Ashikaga painters there had come an end to what, for want of a better word, may be called lyric poetry. There were all the externals of poetry in the works of the Kano and Kōyetsu schools and in the ramifications of later years. But of precisely what I choose to mean by that word — the wedding of appealing expression to a deeply moving idea — there seemed little left. I have spoken about the pure poetry in the nature scenes of the scrolls painted during the Kamakura period and in the profound ink landscapes of the Ashikaga epoch and some of Kōyetsu's work, but I can only point to them without attempting to define. The Great Decorators rhyme most splendidly, so do Kano Tanyū and his followers in faultless scansion. Even the Ukiyo-e masters of the seventeenth and eighteenth centuries execute delicious doggerel in a way that sometimes becomes poetry. But try as they all may, by evoking beloved and familiar themes and by admirable expressive brush stroke, they never again move us as greatly. If there is any validity in my conviction of an enduring Japan, we shall see once more great original poetry where, for the last two and a half centuries, we have been forced to put up with skill and with loveliness alone.

It is entirely appropriate for my purpose that these loosely chronological parts of my essay should come to an end with the seventeenth century. For it has been sufficiently demonstrated that Japan's history is no exception to the rule that changing fashions in a nation's art are so closely linked to other cultural developments that even so partial an attempt

to comprehend them must throw light on the contemporary history. The expulsion of all foreigners during the following two hundred and fifty years and the closing of the country against both Europe and China and the hideous persecution of native and foreign Christians was in marked contrast to the tolerant attitude of Ieyasu the first Tokugawa Shogun. It was due, in the first place, less to *odium theologicum* than to a justifiable mistrust of the foreigner's willingness to refrain from interfering with Japanese affairs of state.

Seven centuries before this all diplomatic contacts with China had come to a close for nearly a hundred and fifty years. But that particular shutting of the gates had not prevented a certain amount of intermittent trade nor shut off individual Japanese pilgrims who continued to make their way in decreasing numbers to carry on their studies in Chinese monasteries. It had, however, brought to an end such an inrush of cultural stimulus as perhaps has not been paralleled in the history of any other country. If that first flood had not been mercifully checked in 894, one more century might well have leached away the peculiar virtue from Japanese culture and left the country intellectually and materially little better than a Chinese colony. Concerning that first pause in the fertilizing rush of culture from China one could indeed say, "at last the rich flavor of her own grapes appears in the wine of Japan." But after the closing of the doors on the second occasion one finds the wine increasingly thin, even acrid — past its prime. Japanese culture, hermetically sealed, now changed only in such gradual ways as a sealed mixture can develop under pressure from its own yeast. The inner stresses that finally cracked the container in 1868 are of course all the more interesting to the student of social history for the very fact of their comparative purity and simplicity. But the arts must have no less oxygen than the other cultural ingredients and, engrossing as it would be to watch the process in a comparative vacuum, that is quite aside from my purpose.

Without the lift and stimulus of the Renaissance in Europe, deprived of even a share in the discoveries of the circumnavigators and philosophers and scientists, with no inter-

national trade in commodities or ideas, it is remarkable that when at last the gates of Japan were opened on the second occasion her initiative had not been entirely smothered. An economic materialist would find cause enough for despair in the facts that during those years of national isolation no sea-going ships had left her ports and that the crowded country had been practically confined to a monoculture of rice, with no outlets in time of plenty or chance for import during famine.

In the following chapters I shall abandon all attempts at chronology in order to touch on several aspects of the national art which come slanting across the centuries profoundly affecting the texture of the whole. One of these is the folk art without which aristocratic art could have had no secure foundation. Another is the development of a shorthand convention in painting, inherited from the Chinese, by which, naturalism being neglected, the artist is freed from the bonds of shape and able to concentrate on spiritual significance. The last concerns the transcendental force of Zen Buddhism which formed a peculiar national taste, briefly illustrated though not explained by the art of gardens and the ceremony of tea.

# SEVEN

## FOLK AND TRADITIONAL ART

IT IS WISE TO SPEND A MOMENT TO DISTINGUISH those common objects which are the subject of this chapter from the aristocratic things that are usually considered more important. In the first place we often make the mistake of taking it for granted that objects produced by the people are purely utilitarian and, by contrast, that aristocratic and individual art is usually limited to the high uses of the spirit as distinct from those of the body. I could show you humble religious paintings as well as esoteric masterpieces, scriptures written in gold pigment on purple by famous calligraphers as well as *ex votos* painted by the score to hang in the village shrine against pox and ringworm and crop failure. You will see that the distinction is not one between high and low purpose but of the cheap against the costly, the common against the unique, the simple against the artful, the natural against the self-conscious.

Since I know that my devotion to folk art will lay me open to the charge of preferring it to signed masterpieces, let me say at once that the latter are, by definition, superior. Those great works are safe, they cannot be dethroned. My interest here is to suggest fresh delights in the humble arts and, if you insist on comparisons and contrasts, to demonstrate that these are by far the most reliable documents of the spiritual as well as the physical life of any people. In that sense — and that sense alone — folk art might be considered more important. But sociology is not my subject and I am anxious to share a certain aesthetic enjoyment which undoubtedly exists in very subtle ways in folk art.

For the traditional arts make up a rich crowded seedbed of sturdy plants out of which an occasional aristocratic giant of the species grows up to top the others. Such giants are of significance to us only when they are of the same species as the lowly ones and planted to fulfill our need. To know anything of the Sesshūs and Unkeis in Japan — really to comprehend them — we must first familiarize ourselves with the true beauties of the Japanese normal everyday things. This is not, of course, in order to measure the precise height of genius or to find out how far it overtops the general level but, quite simply, to make certain whether genius and individuality produce the crop we want. Thus, only when one has a realizing sense of Japanese lacquer in general can one presume to savor the master Kōrin (Fig. 60); only when the unconsidered, useful Buddhas of the crossroads have been part of our lives, does the true glory of the Kwannon at Chūguji (Fig. 1) burst upon us.

How then does one define this common art which I find so admirable? Unless it is inferior, how is one to differentiate it from the things produced by great individuals, things labeled by common consent as masterworks? I can hear you ask whether I am about to claim that folk art is more beautiful, for beauty, it is the modern fashion to say, is the only criterion of art. But it must be kept in mind that in Japan and usually elsewhere folk art has been for centuries the work of professionals, seldom the casual whittlings of long winter evenings in the farmer's cottage. He and his family do fashion necessary clothes and furniture, but on the whole the traditions are carried on by craftsmen, devoted to their specialties and owners of the special tools required — forge, kiln, lathe, or dye vat — and with the particular skills. Thus folk objects are not usually distinguished by being made by amateurs and can be defined less by the status of the makers than by the humble economic capacities of the consumers.

It is worth pointing out some characteristics of folk art which will help us to derive from it an enduring and constantly renewed delight. In the first place these objects differ from their aristocratic cousins in that they are not unique or

even rare, that they are usually fashioned from less precious material, and that, for the most part, they lack obvious embellishment or what ornament they have is kept within the strait limits of essential fashioning.

As for uniqueness or rarity we are agreed, I am sure, that however important those qualities may be to the collector of postage stamps, rarity makes a work of art no whit more desirable to the patron or enjoyer. I should go further and say on the other hand that, though commonness contains no element of beauty or of nonbeauty, commonness of good things is so desirable that some conscientious citizens spend their lives trying to make beautiful and useful things available to rich and poor alike.

The next thing that distinguishes folk art is the fact that much of it is fashioned from materials less costly than those available to the rich. But here again plutocracy has no virtue except that wealth can secure materials more adequate for their purpose than poverty affords — fireproof tiles instead of thatch for roofing, sound clear-grained timber instead of stuff weakened by knots and so on.

There remains for examination the third main difference between the folk arts and those usually considered more desirable. That is, as I have said, that folk arts either lack embellishment or what they do possess is confined within the strait limits of their essential fashioning. At this point I might have taken unfair advantage of recent fashion to speak of functional design. I should have thus won to my side a whole generation of honest but sometimes thoughtless people who, anxious to be rid of a plethora of bad decoration, hurriedly pour out the baby with the bath water. But I have promised to play the game fair and in a moment we are coming to certain examples of aristocratic as well as folk art which cannot be examined by the light of obvious utilitarian function — such things as religious paintings and sculpture.

To come back to the subjects of ornament indulged in by rich and poor, those things which have merely more embellishment than others are obviously not to be desired for

that reason alone, because ornament can be judged solely by its quality, never by its amount. The only question pertinent to ask here is: can we discover anything inherent in moneyed patronage which allows it to command better artistry?

Yes, riches give the power to select superior artists and can afford to support them while they spend weeks or months on a job which the humble artisan must do in his spare time with a less professional hand. And thus, when society has developed specialists in the arts and crafts, superior individuals have always emerged from the majority who have been patronized by the rich and whose products become separated from the art of the folk as being definitely out of reach and more precious.

In Japan as everywhere else, the making of superior masterworks, available to the rich alone by reason of costly material or costly labor, seems to be liable to certain diseases and degenerations. These diseases are peculiar to delicate and aristocratic organisms and they never attack our rugged peasants.

The degenerating tendency to which plutocratic art is subject lays it open to the factitious glamor of rarity — a hothouse frailty which sometimes has a particular appeal to snobbish and thoughtless patrons. Real values are, by them, confused with money values or estimated by the fame of the signatures rather than fitness to supply our bodily or spiritual wants. From there it is but a step before we find that artists have lately been segregated as specially endowed persons who, alone, are capable of telling us what we want. The patron, the user, the enjoyer abdicates his right place in society to permit an artist who can never know our wants to be installed as arbiter. Then along come the dealers, who are neither primarily enjoyers nor always critical users, and who try in their turn to persuade us that we can not keep up with the Joneses unless we purchase what the dealers have in stock. Thus grows up the cult of the antique, the cult of the modern, the cult of the unintelligible, the cult of the merely different and, today, the cult of folk art.

Coomaraswamy has pointed out that hieratic and folk

art are traditional and thus represent the only true main expression accepted by a united people. These are therefore called in India the highway, or main road, in contradistinction to the art of individual masters or of academies, which are bypaths. He says: "An academic art . . . however great its prestige, and however fashionable it may be, can very well be and is, usually, of an anti-traditional, personal, profane and sentimental sort." By personal and profane he emphasizes that it lies apart from the unanimous religious conception of the community. By sentimental he means that academies do not concern themselves with the needs of the community but with some manner of rendering which has proved popular or with some current fashion of subject matter. An individual genius, however his accomplishment may astonish and delight us, will always express himself and will therefore necessarily be of less significance than an artist who expresses us all.

The work of single genius will appeal more immediately than any example of a similar sort made by an artist less remarkable for special talent. The delight taken in such a work of art may, however, prove on examination to be purely aesthetic, emotional, and, as Coomaraswamy says, sentimental. Folk art is frequently less obviously lovely but is likely to fulfill its function as well or better, to be immune from the diseases of snobbery, plutocracy, and the cults. Further, since it depends for its very life on the main streams of the culture that produces it, it is usually found to correspond to the three transcendentals — the Good, the True, and the Beautiful. The scholar who concerns himself with such eternal values finds, in some folk art, an enduring quality that places it beyond the whims of fashion and, in this important sense at least, makes it superior to individual and unique art.

It is easy enough to continue what may seem like shadow-boxing at bad art and the follies of society. What — I hear you say — is the matter with great works of art produced by masters? Wherein lies the peculiar virtue of common things, well enough made and admittedly not unattractive? Now I do not propose to set up folk art as a measuring stick nor to

overvalue its merely negative virtues. For Japanese folk art, like that of any other people — stripped of rarity, lacking all price, never having been tricked out with individuality or any other factitious quality — stands on its own legs to hand on its plain message.

This message can be understood only if the originals are examined in the light of their fitness for their purpose. That in itself is not an easy task for Americans unfamiliar with the bodily and spiritual needs of the Japanese people. More than a little knowledge of history, climate, sociology, and comparative religion should be brought into play before one can obtain sympathetic understanding of Japanese needs and the art that supplies them. This is a higher and more discriminating scholarship than memorizing artists' dates or tracing their influences or dwelling on their aesthetics.

Having found, then, how truly fit the products of the people are for the purposes of those who made them, the next thing is to know — really to know — the skill of the makers. For it is one illuminating thing to understand why they were made and another, equally illuminating, to know how. Here again the outsider may be naïvely surprised to find himself an untrained observer. For this is a half-blind generation, ignorant of the lovely qualities of cut wood, and the flexible brush charged with India ink, and the governing of thread patterns on the simplest loom — and even of how potter's wheel and kiln fire transmute common clay. We must rediscover these things. For convenience has smothered the deep satisfactions and wisdom which only poverty and the need to make things can provide. Lacking knowledge of a thing's fitness for its high or humble task, ignorant of the most essential elements of making that bring success or failure, can we honestly love or hate any man-made thing — Sesshū scroll or straw sandal — however much some superficial color or pattern on it may tickle or revolt our emotions?

Turn then to a peasant-made picture where the foreigner is not blinded by the flash of a master's signed name or by any dexterity beyond that admirable skill which comes with practice (Figs. 62–64). Now hear what my friend Yanagi

Sōetsu says about some pictures peddled a century and a half ago, penny plain and tuppence colored, among the daily crowd that thronged Ōtsu village, the northern barrier to the great city of Kyoto: "The Ōtsu picture is a commonplace work done by common people and sold to the public. It is unsigned and undated — without insistence on individuality. Any one heir to that tradition could paint such a picture if he but abandon all claim to being an artist and to the right of self-expression. Here was a domain where no individual liberty was valued, or possible. Cheap stuff and a common thing. It must have no extraordinariness whatever. It is a picture done with sweat, not with mood or caprice. It is the artisan's livelihood. In short it is but folk art — the product of no artistic ambition."

So candid a presentation of the facts may well disappoint readers who are children of our individualistic age. To them the qualities which I find excellent in the Ōtsu paintings are not excellent. And yet I question after all if these are not precious qualities. For several hundred years, in the West, people have been losing something of the right notion of beauty that is ordinary and have largely stopped making common things beautifully. Surely in the past ordinary things have been made in the West by unnamed craftsmen in a manner so beautiful and adequate that no genius could do better. Is it not possible that there is a domain in art where genius has no concern?

Now it is this mysterious beauty of the ordinary that gives power and appeal to the paintings of Ōtsu village. Only common people in the strait grip of common tradition could produce these things. If their pictures had been signed the tradition would have been broken and they would have become individual expressions.

Behind the simple composition of these pictures stretches a far background and a wide one. This genuine simplicity is not arrived at in a generation, but out of the labor of forebears, the long experience of the neighborhood. Adequate skill has ripened into a homely pattern of lines and colors that no individual experience could produce.

No fine workmanship or adequate craft can arise without a long tradition behind it and an almost infinite repetition. In Yanagi's perfect phrase: "If the repetition of a machine is the death of all art, the manual repetition by a craftsman is the very mother of skill and skill is the mother of beauty." The individual artist has seldom been a sound craftsman unless he comes from the ranks of his traditional craft. The charm to us of these Ōtsu paintings (Figs. 63–64) is in their admirable, easy brush stroke, as fit and familiar in our lives as the simple stories and folk proverbs which they illustrate. They were drawn swiftly, but without risk of failure and with no error. And in just this spirit they were accepted, simply and without doubting, by the villagers.

Some may object that Ōtsu pictures were crude. That is certainly true in the worst cases. But such a crudeness is no disease, it came from the very flush of health. True folk art has neither sensuality nor sentimentalism nor abnormality. The simplicity of the best folk art is not real crudeness. It is essentiality. The quintessence has become visible when unnecessary parts have never been added. It is condensed, a crystalized art. Nothing further can be taken from it without violence to the meaning, and yet everything essential remains.

Such folk paintings represent only an insignificant fragment of the mass of such simply made things. I dwell on them here partly because they include many examples difficult to define as strictly utilitarian and yet inseparable from equally well-made market baskets and tools. Their number should be greatly enlarged to include the lovely work of thatchers, the fences made of lattice or of sturdy decorative bundles of trimmed brush and twigs, the ingenious interlacing of thin boards, the tiled mud walls and, of course, rural and town buildings of infinite variety within the rigorous limits of utility and convention. Concerning the glories of weaving and dyeing and of pottery and of the tools used in the trades there is no space to treat here. (See Figs. 65–67, 71–79.) But I should like to understand more thoroughly the particularly crude, expressive animal carvings (Fig. 68). They surely cannot have been useful even in the sense that the god

Daikoku (Fig. 70) serves to supervise the kitchen. They are hard to imagine as pure decoration but may have been toys beloved by children. To examine such singular awkwardness is to comprehend the adequacy of an object which seems to have nothing to recommend it beyond the fact that it is recognizable.

There are still communities, in the West as in the Orient, where the machine has not destroyed the craft of the hand and where standards of excellence are not confused with those of saleability or corrupted by mass production. Unnamed craftsmen are still working as they have been doing for centuries to produce objects both beautiful and fit.

# EIGHT

## THE TRANSFORMATION
## OF NATURE IN ART

THE TITLE OF THIS CHAPTER I OWE TO DR.
Coomaraswamy, who treated the matter in his customary
profound and illuminating way * but without special refer-
ence to the techniques that are my subject.

Transformation into another language of what the eye
sees has been, of course, the daily preoccupation of painters
always and all over the world. And Westerners, unfamiliar
with the Chinese and Japanese manner and the training that
developed it, will nevertheless recognize a familiar problem
approached by way of an interesting short cut.

This can be demonstrated by a few photographs direct
from nature compared with details in which conventional
brush strokes were employed (Figs. 80–91). My aim is not
to show any resemblance between this artificial form and
nature, but to draw attention to the fact that purely formal
brush strokes which do not copy individual natural shapes
are perfectly successful in representing objects. Further, pre-
cisely the same strokes, assembled to make larger units, may
be used again and again to form different shapes, each as
individual as different words composed from an alphabet
limited to our familiar twenty-six letters or as the unlimited
sums from ten digits. In each case the few units employed
will be discovered to possess a virtue and a life of their own
quite apart from the subject they so perfectly express, yet,
separated from their context, they prove to have no meaning.
Nor will they have any beauty except to the extent they

* A. K. Coomaraswamy, *The Transformation of Nature in Art*, Cambridge
(Mass.), 1934.

conform to the accepted convention of the Oriental brush.

Coomaraswamy has written: "It is a general rule in Asia that all works of art have definite and commonly understood meanings apart from any aesthetic perfection of the work itself." And again he writes in speaking of Indian art: "Those who wish to study the 'development' of Oriental art must emancipate themselves entirely from the innate European tendency to use a supposedly greater or less degree of the observation of nature as a measuring rod by which to recognize aesthetic merit."

Once the Westerner accepts the principle of a limited alphabet capable of representing any variety of objects, he is free from the need or desire to copy the chance shapes in nature and can more easily cross the second seeming barrier between us and some of the most important schools of Oriental art. For in certain of these a landscape, a human figure, a pine, or a mountain is deliberately planned for the sole purpose of representing — not only something beyond its seeming shape — but a definitely recognized philosophical, religious, or imaginative concept that cannot be understood except through symbols commonly accepted in that culture. These symbols might of course equally be words or pictures or music or dramatic dance.

The significant fact is that they quite fail of their purpose if they are merely signs to make certain we can identify the subject intellectually — as is the case in the Christian use of St. Catherine's wheel, St. Hubert's stag, and St. Lawrence's grid, which should be called signs rather than symbols, for they point to the meaning but are not themselves the abstract idea. The Cross, on the other hand, and the Lotus have become the Thing Itself, asking of the worshiper only familiarity to tell him not *who* Christ and the Buddha may be, as was the case with the saintly attributes of wheel, stag, and grid, but to merge him, quicker than thought, in the abstract. Thus in Oriental art the thunderhead is not a sign of bad weather nor the plum blossom a sign of spring but, in very fact, immediate disaster or immediate hope.

When the wooden or painted symbol of the god —

whether anthropomorphic or not — fails to be that god, it is of course literal idolatry to worship it. All of which demonstrates again that the aesthete's approach, or that of the art historian, must be quite aside from the meaning of the thing studied or enjoyed. This is worth laboring because our problem is the matter-of-fact question of how symbols in Japan were so successfully used. And we can now trace the manner in which the representation of natural objects bore on such a technical problem as, for instance, the manner of the brush stroke. For in that lies the answer to the question so often asked, "Why don't their pictures look like ours?"

The Oriental craftsman is known, by every testimony — history, tradition, and example — to be unconscious of any standard of judgment on his work of art other than that its subject must be obvious at first sight and, secondarily, that he must give you his uttermost technical skill. A picture of an object is either recognizable without conscious effort or so ill drawn as to be actually unrecognizable, and this does not depend on the beauty of the picture or on the amount of detail included, or on color, or on cast shadows or on any one of the score of different formulas for perspective. There may be in it more or less beauty, more or less skill, but recognizability has no degrees; that is either present or it is absent. His next preoccupation is to bring all his technical ability to bear on perfecting the picture as an artifact, so that his lines may be vigorous, shapely, graceful, and admirably composed. How blessed he is to be free from the chains round the ankles of the Western copyist! Such a Westerner's criterion of excellence may too often lie quite outside what he creates, beyond the bounds of his own canvas, for there are those of us who do not judge him by his skill to make lines, or by his vigor or his imagination, but by mere likeness to God's handiwork on the model stand. Take away all other meaning and content and what a pickle the copyist from nature is in!

Just here, in parenthesis, one begins to sympathize with the modern Western painter, fed up with photographic likeness and mere recognizability. Properly anxious not to be tied

down to surface facts, still he lives in a world of no religion and little philosophy to express. A few of his contemporaries demand verisimilitude, many more want loveliness in the original, and some are content with a "new look" which they call originality. Worse still, there is today no common language of symbols, understood by us all, such as the Orientals and the pre-Reformation Europeans used.

The purpose of illustrating these formal brush strokes (see especially Figs. 85, 87) is to demonstrate them stripped of their meaning and to show the manner in which the Orientals employ a convention. By this means they freed themselves from the need or desire to achieve copies of nature any more accurate than was necessary to secure recognition. They were then at liberty to devote their mind to the infinitely harder task of suggesting meaning, and their skill to doing it adequately. The West has sometimes been engrossed in making facsimiles of curves and surfaces and colors which would increase the likeness to the object rather than to what the object stands for. *Tromper l'oeil* would not be their goal, but *tromper l'imagination*. The inner meaning of a subject should be understood when it is supremely accurately rendered by art. But the wise Orientals long ago discovered the danger of becoming engrossed in accuracy at the expense of significance. They believed that the essential truth could be better caught by an artist when he pierced through, or even neglected, externals. He rendered these by conventional short cuts and concentrated on inviting the essential idea to possess his brush.

The painter had only our familiar natural objects to use for symbols. Born with that amazing tool, the Oriental writing brush, in his hand, and trained from infancy to draw graceful ideographs, he used these same formalized brush strokes in drawing, for example, pine trees and mountains and rocks and cataracts, which were his familiar symbols for abstract ideas. The onlooker must, in each composition, see not a pine tree, still less a particular pine tree, but the very symbol of firm deep-rootedness and of quiet life which the pine tree is. Bamboo is the symbol of graceful yielding, springing back to its posture after the gales, and the rock by the

waterfall is a contrast of stability with everlasting flux — never the same water, eternally the same falls, always the rock (Fig. 92).

The brush strokes they assembled to represent natural objects became by degrees more formalized, and more and more stress was laid on their exquisite calligraphical execution. So there grew up outside the main vocabulary of the symbols — rock for steadfastness, bamboo for yielding, etc. — a second language or vocabulary enclosing the first. This one had to do with the mechanics of using the brush; one style was virile, another was elegant, still others were honest or hasty or decorative. Thus the master conveys, when writing words or drawing pictures, the varying moods of different subjects and at the same time he infuses them with something of his individual nature. But so far as I know, no Westerner has ever lived to become master of the Oriental brush and very few have made even the first steps toward comprehending this subtle language of calligraphic manner.

The shorthand method of conventional brush strokes developed to represent natural objects was learned by rote and practiced piecemeal — meaningless until assembled, an alphabet, in fact. It thus came about, even before the decadence and the complete academicizing of techniques, that to draw these needful strokes was, after years of practice, quite as instinctive as to strike the needful notes on the piano. No conscious selection is needed in either case, for the idea is converted forthwith to the correct symbol, without in the one case looking at the keyboard to count black and white notes up or down from middle C or, in the case of the painter, glancing at the model and back to make outlines that conform to it. The names of the separate strokes were not according to the things they represented but based on chance resemblances. The stroke for a bunch of pine-needles would be called "crab claw," rock formations would be "cleft by a big ax," "cleft by a little ax," "horse's tooth," "alum crystal," or the like. Wrinkles on the mountain are "raveled rope" or "cow's shoulder."

It is true with piano as with brush that the work of art is

a mental image, and a trained practitioner's instinct short-circuits the old trial-and-error system which at best ends in a mere approximation of the shape of the model. But, using conventional symbols, there can be perfect "accuracy" — the shorthand units are simple and comparatively few and are thoroughly comprehended, visually as well as intellectually, by the artist and by the entire culture in which he dwells.

The brush strokes are practiced as the Chinese and Japanese characters are practiced; both must be perfect before a painter or a calligrapher can set to work, and the same type of brush and paper serves both purposes. Once a painter knows the conventions of "raveled rope" or "cow's shoulder" he is equipped with basic symbols used by Sesshū himself and by the village potter to decorate his rice bowl.

# NINE

## TEA, GARDENS, AND ZEN

WHAT ONE CAN SAY ABOUT THE FORCE EX-
erted by the tea ceremony on so many facets of Japanese
culture since the fifteenth century is far short of the truth.
The mystery is that so restrained and rigorous an aesthetic has
thoroughly flavored the life and tastes of a nation which could
never have entirely comprehended such refinements, at least
as a nation, and which includes its proper share of vulgarians
and insensitive people.

There is danger in attributing to a whole nation some
tendency the outsider finds charming in his contacts with a
cultivated and enlightened few. Yet it must be recognized
that generations of craftsmen have unquestionably produced
architecture, pottery, textiles, and all the necessary endless
furniture for living in a manner conforming to the reticent,
demure taste of the Zen practitioners and of tea. This phe-
nomenon must indicate something more than a blind ability
on the part of the artisans to cater to a philosophy for which
they lacked all sympathy or comprehension. I have been
seated on the threshold of the shop of a simple craftsman and
given tea made in an unglazed pot of common Chinese I-hsing
ware. I did not realize till I took my leave that I had shared
in a genuine tea ceremony. Even to some of the more formal
details — the requisite number of sips, talk about the tea pot
and its age and provenance, down to the *negoro* lacquer tray
from which the color had been scrubbed by generations of
use — we had conformed to the gentle rigors of Zen and tea.

The best understanding of the subject is to be found by
the Westerner in Okakura's *Book of Tea*. There, in delicate
English prose, is set down something of the spirit and the
austerity of restraint which practice in the art of tea serving

(for it is an art) engenders. I can but suggest the mood and the circumstances of the tea ceremony, for we have all been conscious of such a mood even if the circumstances are seldom deliberately practiced in the West and the atmosphere, with us, can hardly be consciously evoked.

Imagine, then, a Japanese gathering of four or five old cronies, imbued with the spirit of Zen philosophy, in a tiny room bare except for the gear of tea drinking — the hearth for charcoal set in the floor, the big iron kettle and the crane-wing hearth brush and a single picture in the niche with a flower arrangement set below.

The substance hidden under this simple shape is no esoteric Oriental affair, but something so common to humanity the world over that we all can grasp it. Origins and the history of the cult aside, it consists in a meeting of chosen spirits who have much to talk over. It is not accident that the national taste had made them predominantly interested in each other's art treasures and that the talk concerning these has directed the conversational channel now associated with tea. But I have heard the talk swing about to the local folklore and the archaeology of the neighborhood, to abstractions of philosophy, and to a disputed fact in history. And all the time the ceremony — if indeed it was that — has moved on its appointed course.

The instinct which has developed the tea ceremony exists universally, where a certain civility and leisure exist. Add that in Japan it has been the serious diversion for the best minds, that the philosophers have developed all the significance of using simple, even crude, utensils and have loved particularly those associated with past generations; then one begins to comprehend what the tea master may select for his garden and his gear.

His tearoom is a thatched cottage suggesting refined poverty and its setting may be a pine grove with vistas cut, the banks of a mountain brook where pure water for tea is at hand, or a garden set with shrubs and an occasional ancient pine. Just within sight of the low door, outside which entering guests will leave their shoes, is a bench for them to sit

on till their number — four or five — is complete, and the
signal comes that the host is ready.

Great care is lavished on this spot and all that is in view.
From the bench, perhaps sheltered by a thatch, the path leads
down to a stone water-basin beside the teahouse door. This
path, long or short, is the tea master's garden. A thousand
arts have been employed to make it suggest the wood or the
mountain path or the temple close. It is most successful when
one becomes convinced in traversing its few yards, that here,
quite by chance, one has come across the dwelling of a retired
gentleman, living remote and sufficient to himself. Here, one
sees at once, will be found simple hospitality and good talk
from some old man who has the wisdom that comes from
being much alone. Such a person may be a retired minister
of state, sick of the life of courts. He may be a simple country
gentleman fallen on poverty and quite content. One looks
forward to a talk with him and to handling the well-worn
bamboo spoon that, years ago, he whittled to scoop out his
tea. Here, best of all places, can be settled that vexed question
of the ancient pottery kiln said to have been once the pride
of the village in the valley. Surely some of its make will have
been handed down in this man's family and he can set one
right about the matter of the generations of the master crafts-
men.

That path to the cottage door has demonstrated what a
single garden can do, and you may ring the changes on it
without limit and arrange your garden to suit any taste, from
pleasant folly to a knowledge of the Absolute. It is no
mystery that tea masters, with their Zen Buddhist cast of
mind, should have made the most valuable contributions to
the gardens of Japan.

It seems unkind and hardly necessary in this connection
to add that serving tea, like other arts, has from time to time
in the hands of lesser spirits become frozen into intolerable
correctness. Three or four hours can seem like a lifetime if
they are spent on one's knees in deadly terror of omitting
one of the hundred ritual motions in handling the tea bowl
or setting down the caddy or neglecting, in proper phrase,

to compliment the host on his arrangement of flowers. Yet that is what a properly brought up young girl must frequently undergo during the process of learning what the Victorians called Deportment. Even the vocabulary and the phrases used, as well as their sequence in the order of events, have been decreed by the professional instructors. At a professional's house one longs for the presence of some guest who, keeping insensibly within the unmarked boundaries of appropriate subjects, creates an atmosphere of human intercourse quite unrestrained except by a sensitive regard for other people.

There have been periods in Japanese history when teaism became the rage — and rage is perhaps of all things most contradictory to the mood of tea. Vulgarians, anxious to purchase a reputation for culture, outbid each other for famous tea bowls and tea caddies. Incapable of critical judgment of the objects, they paid outrageously for things already made famous through association with famous tea masters — a kind of snobbery not unfamiliar in the West and precisely that fostered by our book dealers to tempt collectors by means of association values.

There is a delightful Korean peasant rice bowl called the Ido, which has half a dozen brocaded bags, kimono for the different seasons, and which lives in five boxes each inscribed by one of its former owners. It was brought back from the Taikō's Korean campaign in the early seventeenth century by a famous general, fell into the discriminating hands of one of the most accomplished tea masters, was used more than once by the Shogun and finally, twenty years ago, was sold for one hundred and eighty-nine thousand yen, which, at that time, amounted to ninety-eight thousand five hundred American gold dollars.

There was at the same sale a three-inch pottery tea caddy of demure exterior and, like the Ido, without embellishment, that sold for the equivalent of sixty-four thousand five hundred American gold dollars, and a tea scoop whittled out of a bamboo splinter that fell, under the same furious bidding, for fifteen thousand dollars gold. No one of these objects had

the slightest intrinsic worth beyond any five-and-ten-cent-store bowl or caddy or scoop. Without its records in the Burke's Peerage of such things no one of them would have fetched a dollar or two.

While this Emperor of all tea bowls is in our minds, it is worth a moment's study to discover everything that real discrimination, shorn of association and snobbery, can do to give it value. Most important is the fact that it comes nearly as close as any man-made object can come to possessing the incomparable beauties of a natural object. Fire has had its unpredictable way with clay and dull, colorless glaze and no man has embellished it. The result, in this particular case, happens to be as lovely a thing as a mottled stone one brings in from the beach to the writing desk. There is infinite variety. Use, and much careful wiping and the stain of tea juice have insensibly given it patination as the waves gave the stone. If, in addition to what the eye sees, one admits its undeniable utility nothing is left to explain its price in the twentieth century except the very human attribute of association with glorious names. The set of ivory false teeth made for George Washington by Paul Revere has indeed similar association for an American but may lack the other more endearing qualities. Who but a dealer can guess what some patriot might pay for them?

Among the scores, even hundreds, of stories told to illustrate the very real delicacy and discrimination that tea inculcates is one about Sen Rikyū, the famous tea master, seventeen generations before the present master of that name, who went with his son to call on a fellow practitioner of tea and to examine his garden. The son admired the moss-grown wooden gate that opened to the path toward the door of the thatched tea hut. But his father said: "I don't agree. That gate must have been brought from some distant mountain temple at obvious expense. A rough wicket made by the local farmer would give the place a really quiet and lonely look, and not offend us by bringing up thoughts of difficulty and expense. I doubt if we shall find here any very sensitive or interesting tea ceremony."

Thus, on the whole, the really significant thing about the cult and practice of tea is that, in spite of occasional perversion of its very principles, no other custom in Japan can illustrate so perfectly the sensitive side of Japanese nature and no other force, unless that of Zen Buddhism which is close to it, has been so powerful to inculcate simplicity, directness, and self-restraint — in short, discriminating taste.

### GARDENS

The fundamental thing about Japanese gardens, and what sets them apart from any other gardens of the civilized world, is usually lost sight of by Westerners. It is the fact that the art was definitely used in China and Japan to express the highest truths of religion and philosophy precisely as other civilizations have made use of the arts of literature and painting, of ritual dance and music. The Japanese tell us that the Chinese developed the garden art as a means of communicating high philosophical truths and, judging by their Sung dynasty paintings, it seems certain that they did. But since whatever the Sung Chinese have done in the past assumes a halo of admired classicism and of nostalgic admiration to the Japanese, my guess is that there may have been less deliberate philosophic intention on the part of the classical Chinese garden designers than has been assumed. There remain, however, noble Chinese paintings from the twelfth to the seventeenth centuries that bear witness to a garden school — certainly a garden taste — of great subtlety and beauty. Of course, for splendid city and park and palace planning the Chinese had no superiors.

The Westerner is always attracted to the art of gardens in Japan not only by the obvious beauty of the accomplishment, but by vague hints that have reached him of the philosophical and emblematic content of that art. Our ignorance of this part of the subject is profound, and therefore we are in danger of indulging in sentimentality. Certain Japanese

have been guilty of this same sin, but these have usually been writers about gardening, not gardeners.

The philosophic and symbolic content of the gardener's art is precisely that of any other important form of expression — neither less nor more. It is not the original cause of garden-making nor, generally, its purpose. Philosophy may well, however, come into play before the arrangement, selection, and elimination which are the art itself, and before horticulture, which is the craftsman's palette. One is tempted to dogmatize and say that philosophy about a garden is never permissible unless one has sweat to lay it out and labored over planting rocks, spreading the roots of young trees in pulverized soil, and leading ductile streams of water in their fit channels. But it would be just as true to say that no man should invoke the aid of a religious painting for worship until he had ground the pigments and himself laid them on the canvas.

This being so, it is proper to consider, so far as a Westerner may, something of the spiritual symbolism that has been expressed in the gardens laid out by Zen philosophers and has filtered down from them to the gardens made for and by laymen.

A Japanese mind, filled with half-memories of poems and paintings evoked by garden surroundings, will recognize through the power of association the *yang-yin* (male-female, light-dark, strong-weak) principles of pre-Confucian philosophy. And profound truths of many sorts, concerning even the essence of God, may be the result of thoughts thus deliberately evoked in a garden. Or again, if suggested by a not too farfetched likeness, a group of rocks can be recognized as the dragon and her cubs where they sport in the spray of the cataract. And, from knowledge of the dragon kind, one will be led to profitable thinking on the forces of nature, benign or dreadful, and on the origin of all things in mist and water.

Certain gardens have been designed primarily to call up such ideas, and it is important to record the fact that they have been in the past, and are today, successful. Further,

these gardens are not mere curious documents, but have exerted a vital influence on the art of gardens in the East.

But for us to copy such forms would be absurd, though the Westerner may gain much by a study of the art as it is practiced in Japan. For instance, observe the close wedding of the garden scheme with the dwelling, which the Japanese planner of gardens achieves by spending many days contemplating the site in various weathers and at all hours of the day. He makes small use of plans or sketches, but has a basket of pegs which he occasionally drives in the ground as he walks. Here and there he will set up a high bamboo pole to which have been lashed crosspieces that represent the spread of the branches of some tree he is to bring in. Thus he visualizes, by degrees, the whole area at his disposal, constantly returning to one another part of the grounds to make sure that a vista is preserved or that a distant path is revealed. The scheme develops and shifts under his hand. And when men bring loads of rock and earth and trees with tightly balled roots, he hovers about to make sure that rocks are set to lie as the geologist would have them and that each tree's umbrage is to the sun. When his stream bed is done, its angles and its curves are those of nature, and the beaches are placed in those coves where running water would drop its load of gravel and of sand. So much is mere copying of nature's manner of working if you will, and in that sense it is like the work of the landscape painter when he contrives his own compositions. When all is done, with close regard to nature, step back into the open room of the house and sit with your tea, looking out. There water glints. But what its farthest stretch may be you do not know. The suggestion is that the stream flows on through pleasant country to an ocean miles away. The steppingstones that cross its narrowest place lead to a dip on the further bank beyond which the path accepts an invitation to climb and then hides in a thicket to come in view again further downstream where it skirts a little beach.

Thus the Zen practice is realized in the teasing charm of incompleteness — the suggestion that the onlooker finish his own idea according to his own imagination.

## ZEN

We have seen the Buddhist religion spread like some benign irresistible flood over the land to fertilize it and we have seen how the arts were nourished. There are available whole libraries of Buddhist texts and translations and exegeses concerning its various doctrines but they cannot be discussed here. It is enough to emphasize that it was all so appealing, so gentle and constructive and contained so little to rouse theological controversy that the tenets of the sects, which had become diverse, won over the intellectuals and then, insensibly, the people.

One of the most interesting phenomena connected with any study of Japanese culture is the emergence from China of the Buddhist sect called Zen in the thirteenth century * and its incalculable control of men's minds and works during later centuries. One speaks of it as emerging because, although some of its tenets can be distinguished early in the eighth century, nothing in the recorded history of Japan previous to the thirteenth century prepares us for the undoubted fact that any so subtle philosophy could actually capture the imagination of the Japanese. Still less could the student of pre-fourteenth century Japan have predicted that the spirit and temper of Zen doctrine could have been passed along, in certain of its aspects, to the illiterate and have been accepted by them.

But the teaching of this one sect in particular has, during six hundred years, furnished to painting and the other arts in a peculiar way something far more subtle than merely a religious iconography, subjects for lay illustration, or an aid to worship or patronage for temple embellishment.

To illustrate something of the variety of the Zen type of mind I have selected paintings, gardens, and the cult developed about the social drinking of tea. These are but three of the hundreds of refinements to be found in Japanese culture which demonstrate the presence of the same ingredient in the soil that encouraged the roots of Zen Buddhism to spread

* See above, Chapter Four, especially quotation from Sansom, pp. 42–43.

so naturally. The paintings (for example, Figs. 50 and 92) not only illustrate Zen subjects but demonstrate by their manner the principles of restraint and swift abbreviated rendering, seemingly careless, that are taught by Zen; gardens show the taste of priests and cultivated laymen and their preference for surroundings where the artifice of arrangement has been carried to such a pitch as almost to obliterate itself and appear to be nature; while the tea ceremony is an extension of philosophy to the sphere of social meetings.

These and a score of similar developments are so closely wedded to Zen Buddhism that they are commonly said to be the results of Zen. But that easy generalization should be modified. It seems more probable, while they undoubtedly owe incalculably to Zen tenets in their later developments, that they are found in the same soil growing in a state of symbiosis, as the biologists call it, rather than existing as parasites on Zen. I would rather say that the climate and soil in Japan since the fourteenth century have fostered equally the tea cult, symbolism in gardens, and the tenets of Zen.

What concerns us in our analysis of Japanese art and the light it throws on the character of the people, is to watch the effect of Zen Buddhism on the national mind and to find it reflected in their art. It is an historical fact that Zen has been significant ever since the warriors in their armed camp at Kamakura in the thirteenth and fourteenth centuries, and their elegant successors the connoisseurs, Shoguns, and painters in the fifteenth, down through all art and all battles and all conduct of life.

It is this flavor and taste of Zen in the mouths of the Japanese which for five hundred years has fostered an art of simple things without glitter and embellishment, a decorous attitude toward other persons and a keen appreciation of all that is suggested rather than stated. Zen habits of mind ran through the warp of Japan to subdue and harmonize the whole fabric.

In the practical matter of putting down their paintings in ink on paper Zen artists discovered that the principle of *muga* (it is not I that am doing this) opens the gate for the neces-

sary essential truth to flow in. When the self does not control the drawing, meaning must. This principle runs all through Zen teachings especially where action is involved. It is related to the Taoist mistrust of the human intervention which clogs the channels of the Way. Abstract as this may seem in the West it has exerted definite influence in the Orient on even so mundane a business as the painters' techniques, for it tends to produce the much admired swiftness in execution, the elimination of detail, and an ability on the part of the artist to make each brush stroke, from the first to the last, serve the single purpose of the essential idea. The style is so abbreviated that nothing remains of embellishment or obvious artistry. The observer is encouraged to enjoy the undoubted delight of exercising his own imaginative powers to grasp the whole.

The technique thus evolved was a shorthand in which not only the subject matter but the very manner of the brush stroke came to be a most expressive vehicle for meaning. Undoubtedly the most vivid examples of this wedding of manner with meaning occur in the Zen paintings of the Sung dynasty in China and the Japanese Zenists in the fifteenth and sixteenth centuries. Also illustrating the doctrines, though not actually picturing their texts, are scores of paintings made during the fifteenth century and during the first half of the sixteenth in Japan. Many were painted by monks but some by laymen imbued with Zen and adept in the swift art of summarizing, in half a dozen strokes, an idea so nearly ineffable that to labor it would be to quench its meaning. There is hardly a better example of Zen meaning and manner than the small album leaf by Sesshū (1420–1506) illustrated in Fig. 92.

There is a deal of documentation on the Japanese form of Zen, but it is brash indeed for a foreigner to attempt to define it, for every Zen teacher has called its essence indefinable. It is almost a definition to say that when one tries to compress it into a definition it is no longer there. Perhaps the English word, the Absolute, is better than anything else, for that is the core of things, the emptiness of the hub of the

wheel where the power of the cart is found, just as an empty jug is the only simon-pure container, capable of holding any liquor, while a full jug is already restricted to but one sort. Infinite Potentiality is another attempt to define it.

From the start Zen dispenses with all forms of theorizing, doctrine, and lifeless formality. Those are the mere symbols of wisdom, "and Zen is founded on an intimate personal experience of the reality to which most forms of religion and philosophy come no nearer than an intellectual or emotional description. . . Zen thrusts all obstacles aside and moves in a direct line to the goal. . . Creeds, dogmas, and philosophical systems amount only to ideas *about* the truth, in the same way as words are not facts but only *about* facts. . . While second-hand wisdom is valuable as a sign post pointing the way, it is too easily mistaken for the goal." *

A poor Zen monk horrified his disciple by splitting up a wooden image of the Buddha for kindling. The shocked acolyte asked him why he did it and the answer was "to find the *shari*" (which are the pearls left when the Buddha's body is cremated). "But," protested the boy, "that is sacrilege. Besides, you'll find no *shari* there." At which his master went on chopping wood, saying, "No *shari*, no sacrilege."

Zen has "no doctrinal teaching, no study of the scriptures, no formal programme of spiritual development. . . Almost the whole of our records of Zen instruction are a number of dialogues (Mondō) between the masters and their disciples which seem to pay so little attention to the usual standards of logic and sound reasoning as to appear at first sight to be nonsense. But Zen does not attempt to be intelligible, that is to say, capable of being understood by the intellect. The method of Zen teaching is to baffle, excite, puzzle, and exhaust the intellect until it is realized that intellection is only thinking *about*. It will provoke, irritate and again exhaust the emotions until it is realized that emotion is only feeling *about*, and then it contrives, when the disciple has been brought to an intellectual and emotional impasse, to bridge the gap be-

* This and following quotations about Zen are from A. W. Watts, *The Spirit of Zen* (London: John Murray, 1936).

tween second-hand conceptual contact with Reality and first-hand experience" of it.

*Satori* (enlightenment) is knowing the world as it really is; not, as some Christians believe conversion to be, something descending from on high that changes the world. "In Zen there is no dualism of Heaven and Earth, natural and supernatural, man and god, material and spiritual, mortal and immortal." Even the word enlightenment so frequently used to express the object of Zen training may wrongly connote duality by suggesting the contrast between light and obscurity. This is contrary to the true conception of the doctrine of universal unity and has, in some cases, been the cause of failure to comprehend the entire Truth. In the same way truth and error may not be contrasted. Truth, being indivisible, embraces its seeming opposite. Dr. Suzuki warns in his *Zen Doctrine of No Mind* that without complete understanding of the dialectic of "negation-affirmation" one has no right to say a word about Zen.

The complete identity of all things — mundane, intellectual, and spiritual — is thus illustrated by the broom, the abbot, and the Buddha:

> Broom said to Buddha
> We saints can never sleep.
>
> Buddha said to broom
> We little folk must sweep.
>
> Old brocaded Abbot
> Smiled as he knelt to broom.
>
> Buddha leaned in cupboard
> While Abbot swept the room.

To obtain knowledge by sitting in solitary meditation is no use. Mix with the world to acquire the thorough conviction that you no longer mistake symbol for reality or confuse the finger pointing at the moon with the moon itself.

In essence the central idea of Zen is, like that of other religions and philosophies, based on the search for truth. Adepts in Zen have discovered, much as the earlier Taoists did, that ratiocination on the subject entangles the thinker

with factual and intellectual conclusions which, however correct so far as they go, may have little bearing on ultimate Truth. Thus words and definitions and even principles are avoided except when they are recognized as mere milestones on the road to enlightenment, useful only to the traveler who keeps the goal steadily in mind and leaves them behind. He constructs a raft when he reaches a river and abandons it as an impediment when he takes again to the road on the far bank. As for the goal itself it can be called only enlightenment, complete realization of the unity of all things. This is known to come in a blinding flash, every idea and every thing falling into its appointed place when looked at from the end of the journey. But the road's end itself is empty of every thing and every idea, for it is indeed sheer Potentiality — the empty nave of the wheel wherein all power is found. This implies no denial of the truth (correctness) of mundane things or even of their separateness, merely that such "things" are finally merged in transcendant Truth. Affirmation rather than negation emerges with the idea that even duality and multiplicity are not incompatible with perfect identity.

The training of the Zen priest toward enlightenment includes intellectual drill but only because the processes of the intellect must be comprehended if, at the end, they are to be thrown overboard. Then the inner flash, *satori*, supersedes them all. This training has given rise to a body of literature consisting of accounts of the manner in which the flash has come to Zen adepts and the patriarchs of the past. These stories are told in the rather wistful hope that people when reading and hearing them may see the light. But each arrives at the goal along a different path from the others. Always it is sudden, inexplicable, and incommunicable. The seeker is then entirely persuaded of the unified truth of all things and comprehends this fact by light from within, never from any outside source. Usually the desired state is the result of some catalyst, or of a sudden jolt, which causes the crystals to assemble abruptly into their proper shape where a moment before all had seemed merely water.

Even more important than sermons and stories of past

sages who achieved the truth are the deceptively simple or the obviously unsolvable questions (*kōan*) given the seeker to ponder: What is the sound of my one hand? Or, why is the capstone of the tower laid first? When such questions are susceptible of logical answer, that is more than likely to be proved by the master to be the wrong one. If, on the other hand, the seeker indulges in some finespun philosophical solution the master may pounce on it insisting on the most practical commonplace answer.

The oneness of truth is often pointed out by answers which seem incompatible with the questions asked.

*Question:* Why did Bodhidharma [the first patriarch] come from India to China?
*Answer:* He never did.
       **Or**
*Question:* Please tell me of the ultimate truth.
*Answer:* The wooden horse neighs against the breeze and the mud-made bull walks over the waves.

To the last one might answer that a wooden horse cannot neigh and if it did so against the breeze the sound would return. So too the bull of mud is no bull at all and the mud from which it is made would be melted in the waves and return to its source. This may of course be a simile for ultimate truth, but it is quite as likely to call for some other interpretation.

When the master perceives that the pupil is on the verge of "crystallizing" and needs only a sudden jar to realize the sum total of truth, he may tweak his nose or kick him from the room. More than once the anguish of a stubbed toe has made the sufferer realize that *this* at least is undeniable and, since he needs no further persuasion of its truth (correctness), he must admit all truth on all levels of reference. Truth in the sense of mere verifiable factual correctness is one thing and abstract truth is another. But such double talk and the use of terms in different frames of reference is not confined to Zen nor is it always slipshod logic. Sometimes it is deliberately employed to demonstrate the fallibility of both logic and nonlogic and the existence of something behind both.

So it comes about that a Zen monk, pondering such dilemmas for years in his monastery, working in the garden and the kitchen and performing in his turn the necessary menial tasks under the strictest self-discipline, can arrive at a state of mind in which the ultimate is understood as pure potentiality where there exist no contradictions or duality or multiplicity. The result, however, differs from somewhat similar theories of Westerners who have invoked or excluded logic in denying reality to the sensible world. Since the Far East never evolved our sort of classical logic nor the newer less cramping forms advocated by Whitehead and Bertrand Russell, the Zenists are free to create a universe which denies neither empirical reasoning nor an ideology largely flavored by religion. They insist on the factual reality of sensual objects. But this is on another level from the truths comprehended by the sages, who regard facts as true and useful in mundane affairs, only to pass them by without denying their existence.

The poor neophyte who has been confronted with dilemmas and conundrums that can neither be affirmed nor denied is persuaded in the end to chuck away all reasoning and depend on intuition, and when the flash of illumination arrives, all seeming inconsistencies he has been trying to reconcile are, to him, at last consistent. Such has always and everywhere been the experience of mystics and it is well for the philosopher to admit from the start, as Russell says in *Our Knowledge of the External World*: "The mystic, so long as he merely reports a positive revelation, can not be refuted; but when he *denies* reality to objects of sense, he may be questioned as to what he means by 'reality.'"

There is a story often told concerning the teaching of the commonplace lesson that things should be practiced in their logical order, first things put first, which pleased the pragmatic generals durign the Kamakura period. A novice asked the Zen patriarch Chao-Chou for instruction concerning the infinite. The master said, "Have you eaten your breakfast yet?" The novice answered, "Yes Sir." "Then wash your rice bowl," said the master.

"Zen discipline [Watts goes on to say] is one of activity and of order; its doctrine the invalidity of doctrine, its end an illumination by immediate experience. The scripture of Zen is written with the characters of heaven, of man, of beasts, of demons, of hundreds of blades of grass, and of thousands of trees. But the Zen artist no more paints from nature than the poet writes from nature; he has been trained according to treatises on style so detailed and explicit that there would seem to be no room left for the operation of personality. And yet immediacy or spontaneity has been more perfectly attained in Zen art than anywhere else . . . there is no kind of art more studied in method, or less labored in effect."

But Zen is by no means only a way to perfecting experience, it is also a way to perfecting character. It represents all and more than we now mean by the word culture; an active principle pervading every aspect of human life, becoming now the chivalry of the warrior, now the grace of the lover, now the habit of the craftsman.

# RECOMMENDED READING

# RECOMMENDED READING

Titles marked with an asterisk have Japanese texts, but are necessary for their illustrations, some of which are identified in English.

## HISTORY AND LITERATURE

Reishauer, E. O. *Japan Past and Present*. New York, 1946.
Sansom, G. B. *Japan, A Short Cultural History*. Rev. ed. New York, 1943.
Waley, Arthur, trans. *The Tale of Genji*. Boston, 1925–33. 6 vols.

## RELIGION

Anesaki, Masaharu. *History of Japanese Religion*. London, 1930.
Eliot, Sir Charles. *Japanese Buddhism*. London [1935].
Henderson, Harold. *The Bamboo Broom*. Japan and London, n.d.
Joly, H. L. *Legend in Japanese Art*. London, 1908.
Okakura, Kakuzo. *The Book of Tea*. New York, 1912.
Reischauer, A. K. *Studies in Japanese Buddhism*. New York, 1917.
Suzuki, Daisetz T. *Introduction to Zen Buddhism*. Kyoto, 1934.

## GENERAL

Anesaki, Masaharu. *Buddhist Art in its Relation to Buddhist Ideals*. Cambridge (Mass.), 1915.
*Dai Nihon Kokuho Zenshu: Catalogue of the National Treasures of Japan*. n.p., 1931– .
Edmunds, W. H. *Pointers and Clues to the Subjects of Chinese and Japanese Art*. London [1934].
Fenollosa, Ernest. *Epochs of Chinese and Japanese Art*. Rev. ed. London, 1921. 2 vols.
Grousset, René. *The Civilizations of the East*. New York, 1934. Vol. IV, Japan.
Guest, G. D., and A. G. Wenley. *Annotated Outlines of the History of Japanese Arts*. Freer Gallery of Art, Smithsonian Institution: Washington, 1941.
Harada, Jiro. *History of Japanese Art*. Tokyo, 1913. Tr. of *Dai Nihon Teikoku Bijutsu Ryakushi*.
———— *Catalogue of Treasures in the Imperial Repository Shōsōin*. Tokyo, 1932.
*Japanese Temples and their Treasures*. Tokyo, 1910. 10 vols.
*Jūdaiji Ōkagami: Catalogue of the Art Treasures of the Ten Great Temples of Nara*. Tokyo, 1932–37. 25 vols. and 4 supplements.
Minamoto, Hoshu. *An Illustrated History of Japanese Art*. Kyoto, 1935. Trans. by H. G. Henderson.
Nakamura, Ichisaburo. *Catalogue of the National Treasures of Paintings and Sculptures in Japan*. Kyoto, 1915.
*Nanto Shichidaiji Ōkagami. Collection of Works of Art from Seven Famous Temples*. Tokyo, 1929.

*Oshima, Yoshiga. *Shōsōin gomotsu zuroku: Catalogue of the Imperial Treasures in the Shōsōin.* English notes. Tokyo, 1928. 12 vols.

*Seizansō Seishō: Illustrated Catalogue of the Nezu Collection.* Text in English and Japanese. Kyoto, 1939–51. 10 vols.

Sirén, Osvald. *Chinese and Japanese Sculptures and Paintings in the National Museum, Stockholm.* London, 1931.

Sōetsu, Yanagi. *Folk Crafts in Japan.* Tokyo, 1936.

*Tajima, Shiichi, ed. *Shimbi Taikan: Selected Relics of Japanese Art.* Text in English and Japanese. Kyoto, 1899–1908. 20 vols.

Taki, Sei-ichi. *Japanese Fine Arts.* Tokyo, 1931.

*Tōyei Shukō: An Illustrated Catalogue of Ancient Imperial Treasure called Shōsōin.* English notes. Rev. ed. Tokyo, 1910 ff. 6 vols.

Tsuda, Noritake. *Handbook of Japanese Art.* Tokyo, 1935.

*Yashiro, Y., and M. Wada. *Bukkyō Bijutsu Shiryō: Materials for the Study of Buddhist Art.* Tokyo [1923]. 3 portfolios pls.

### ARCHITECTURE (AND GARDEN ART)

Cram, R. A. *Impressions of Japanese Architecture.* Boston, 1930.

Kuck, L. E. *The Art of Japanese Gardens.* New York, 1940.

Morse, E. S. *Japanese Homes.* New York, 1886.

Newsom, Samuel. *Japanese Garden Construction.* Tokyo, 1939.

Sadler, A. L. *A Short History of Japanese Architecture.* London, 1941.

Soper, A. C. *The Evolution of Buddhist Architecture in Japan.* Princeton, 1942.

### SCULPTURE

*TōyōBijutsu Taikwan: Selected Masterpieces of Far Eastern Art.* Tokyo, 1918. Vol. XV.

Warner, Langdon. *Japanese Sculpture of the Suiko Period.* New Haven, 1923.

—— *The Craft of the Japanese Sculptor.* New York, 1936.

With, Karl. *Buddhistische Plastik in Japan.* Vienna, 1922.

—— *Die Japanische Plastik.* Berlin, 1923.

### PAINTING

Binyon, Lawrence. *Painting in the Far East.* 4th rev. ed. London, 1934.

Bowie, H. P. *On the Laws of Japanese Painting.* New York, 1951.

*Hōryūji Ōkagami: Hōryūji Kondō Wall-paintings.* Nara, 1918.

Morrison, Arthur. *The Painters of Japan.* New York [1911]. 2 vols.

Naitō, Tōichirō. *The Wall Paintings of Hōryūji.* Baltimore, 1943. Tr. by W. R. B. Acker and B. Rowland, Jr.

*Nihonga Taisei: Illustrations of Japanese Paintings.* Tokyo, 1931–39 vols.

Paine, R. T., Jr. *Catalogue of a Special Exhibition of Japanese Screen Paintings; Birds, Flowers, and Animals.* Boston, 1935.

—— *Catalogue of a Special Exhibition of Japanese Screen Paintings: Landscapes and Figures.* Boston, 1938.

—— *Ten Japanese Paintings in the Museum of Fine Arts, Boston.* New York, 1939.
*\*Seizansō Seishō: Illustrated Catalogue of the Nezu Collection.* Kyoto, 1949. Vol. VIII.
Taki, Sei-ichi. *Three Essays on Oriental Painting.* London, 1910.
Toda, Kenji. *Japanese Scroll Painting.* Chicago, 1935.
*\*Tōyō Bijutsu Taikan: Selected Masterpieces of Far Eastern Art.* Tokyo, 1911–18. Vols. I–VII.

### UKIYO-E PRINTS

Ficke, A. D. *Chats on Japanese Prints.* London, 1915.
Gookin, F. W. *Japanese Colour Prints and their Designers.* New York, 1913.
Henderson, H. G., and L. V. Ledoux. *The Surviving Works of Sharaku.* New York, 1939.
Ledoux, L. V. *Japanese Prints . . . in the Collection of Louis V. Ledoux.* Princeton, 1942–51. 5 vols.
Seidlitz, Woldemar von. *A History of Japanese Colour Prints.* London, 1910. Tr. of *Geschichte des japanischen farben Holzschnitts,* rev. ed. Dresden, 1910.
Tajima, Shiichi. *Masterpieces Selected from the Ukiyo-e School.* Tokyo, 1906–09. 5 vols.

### PERIODICALS

*Bijutsu Kenkyū,* the journal of art studies. Institute of Art Research: Tokyo, 1932 ff.
*Bukkyō Bijutsu* (Buddhist Art), quarterly journal of Buddhist art. Nara, 1924–35.
*Dai Nihon Kokuhō Zenshū,* catalogue of the National Treasures of Japan.
*Kokka,* an illustrated journal of the fine and applied arts of Japan. Tokyo, 1889 ff.
*Memoirs of the Research Department of the Tōyō Bunko.* Irreg. Tokyo, 1926–1938.
*Mingei* (Folk Art).
*Nara.* Irreg. Nara.
*Tōyō Bijutsu* (Eastern Art). Monthly. Nara, 1929–37.

# ILLUSTRATIONS

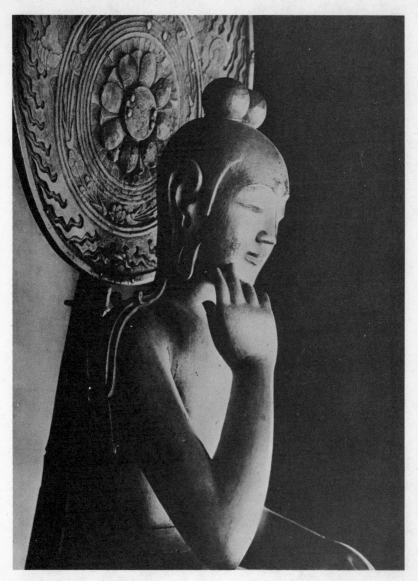

1. *Kwannon or Miroku (detail). Wood. Sixth or seventh century. Chūgūji Nunnery, Nara.*

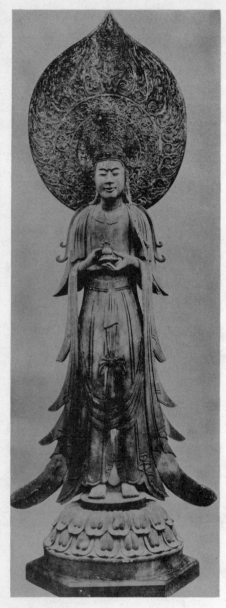 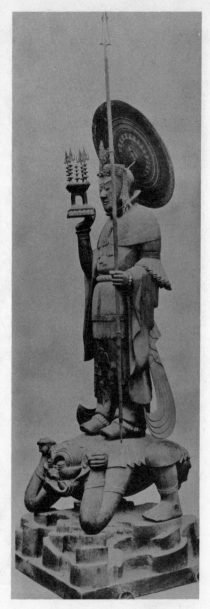

2. *Kwannon. Wood, polychrome. Sixth century. Yumedono Hall, Hōryūji Monastery, Nara.*

3. *Tamon Ten, Buddhist Guardian King. Wood, polychrome. Seventh century. Hōryūji Monastery, Nara.*

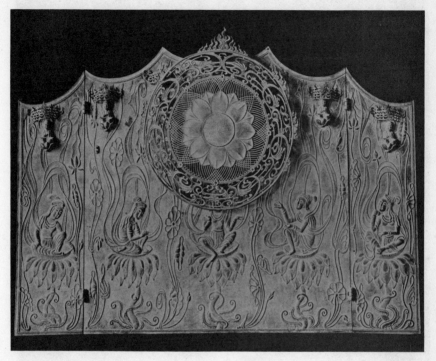

4. *Screen and Halo from Tachibana Fujin Shrine. Bronze. Eighth century. Hōryūji Monastery, Nara.*

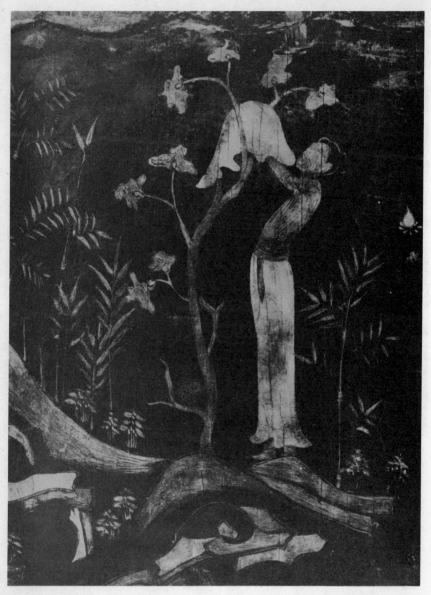

5. *Painted Panel (detail). Seventh century. Tamamushi Shrine, Hōryūji Monastery, Nara.*

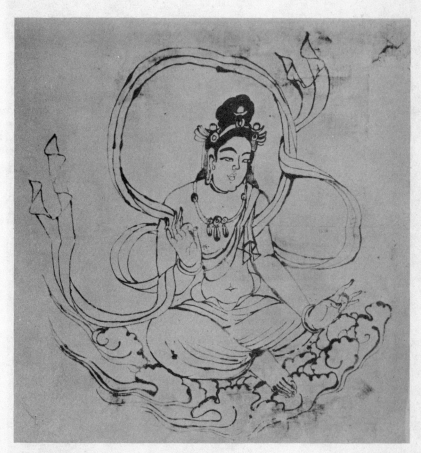

6. *Buddhist Divinity. Ink on hemp. Eighth century. Shōsōin Treasure House, Nara.*

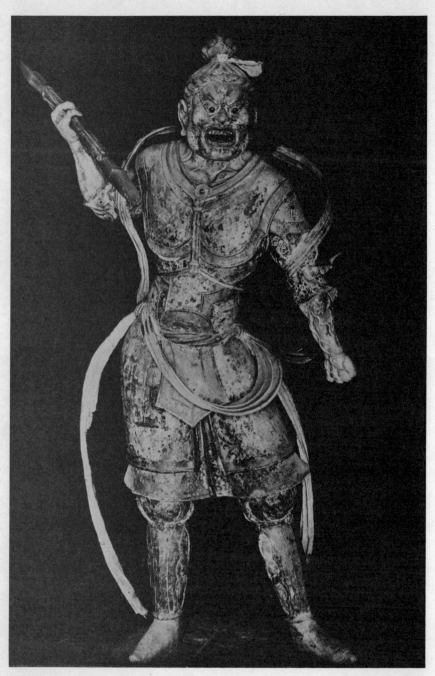

7. *Shukongō-jin. Unbaked clay, polychrome. Eighth century. Sangwatsudō Temple, Tōdaiji Monastery, Nara.*

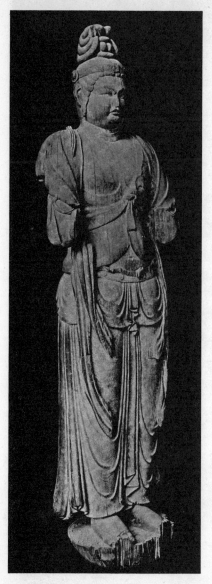
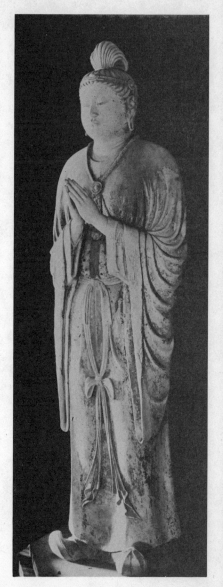

8. *Shuho-O Bosatsu. Wood. Eighth century. Tōshōdaiji Monastery, Nara.*

9. *Bon Ten, or Taishaku Ten. Unbaked clay. Eighth century. Sangwatsudō Temple, Tōdaiji Monastery, Nara.*

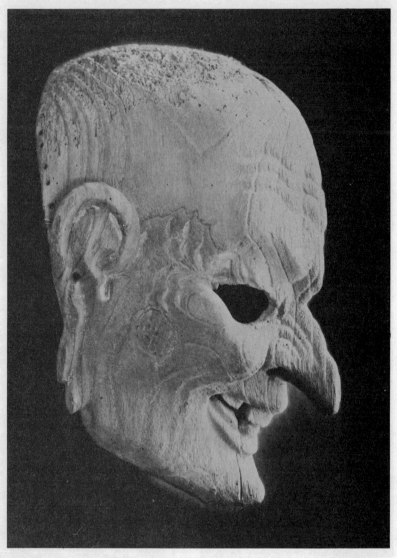

*10. Gigaku Drama Mask. Wood. Eighth century. Tōdaiji Monastery, Nara.*

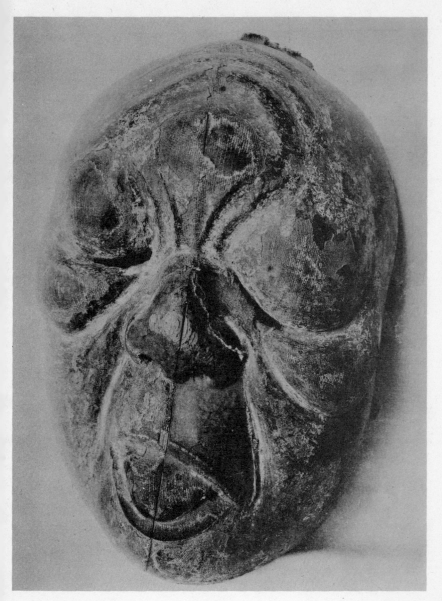

*11. Gigaku Drama Mask. Wood. Eighth century. National Museum, Nara.*

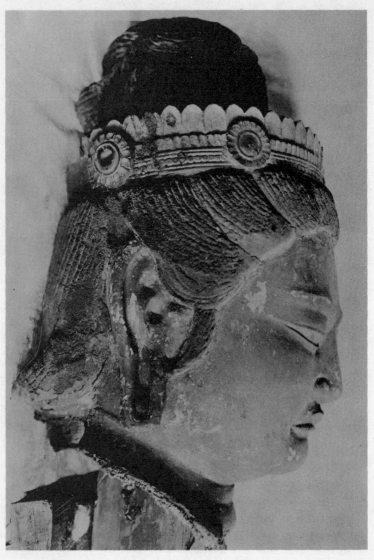

12. *Taishaku Ten, or Bon Ten (detail). Hollow dried lacquer. Eighth century. Akishino Monastery.*

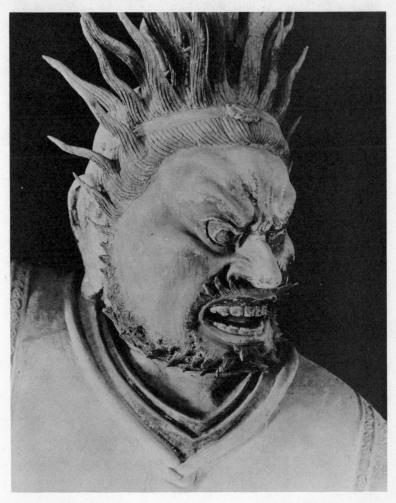

*13. Buddhist Guardian (detail). Hollow dried lacquer. Eighth century. Sangwatsudō Temple, Tōdaiji Monastery, Nara.*

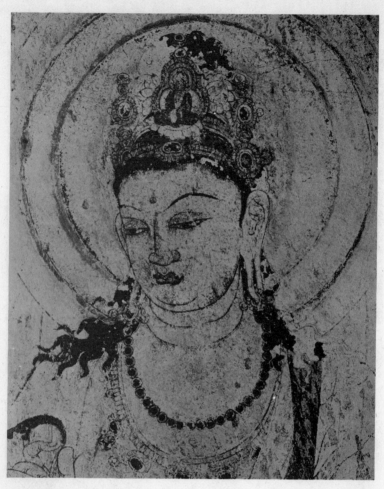

*14. Wall Painting (detail). Polychrome. Eighth century. Golden Hall,*
*Hōryūji Monastery, Nara.*

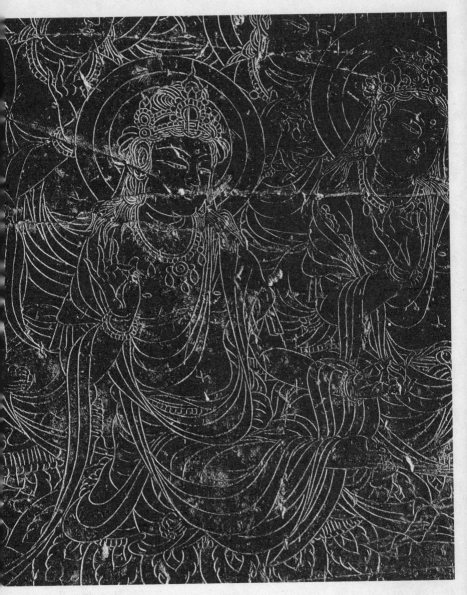

15. *Engraved Lotus Petal* (detail), *Throne of the Great Buddha. Bronze. Eighth century. Tōdaiji Monastery, Nara.*

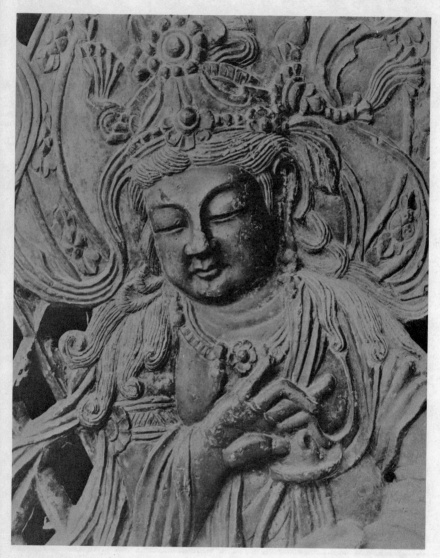

16. *Grille of Lantern Panel (detail). Bronze. Eighth century. Tōdaiji Monastery, Nara.*

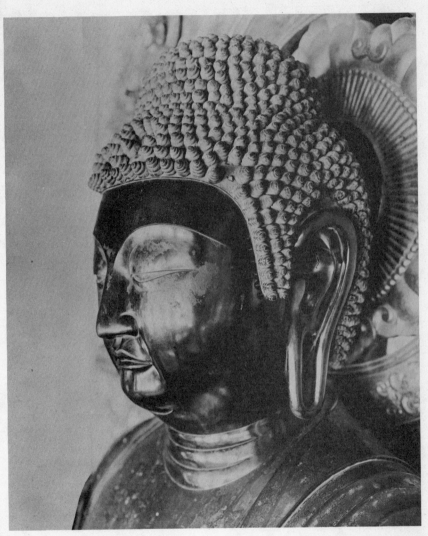

*17. Yakushi (detail). Bronze. Eighth century. Yakushiji Monastery, Nara.*

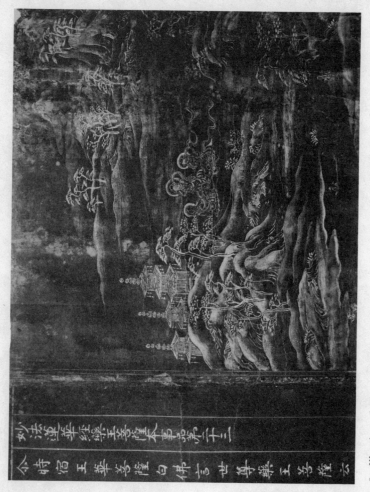

18. *Illuminated Hokke Sutra. Gold on blue paper. Fujiwara period. K. Muto collection, Kobe.*

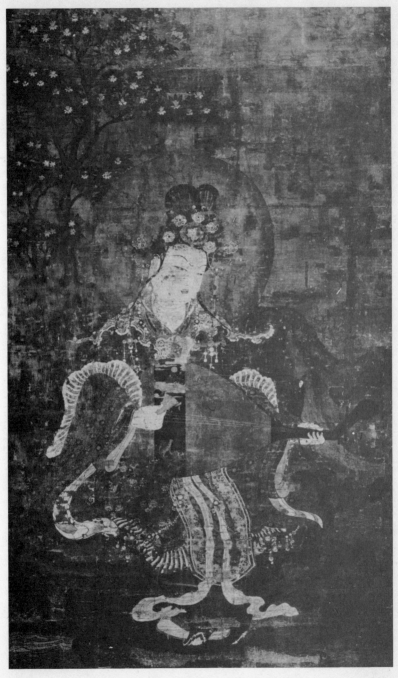

*19. Goddess Ben Ten Playing on the Biwa. Color on silk. Fujiwara style. William Rockhill Nelson Gallery of Art, Kansas City.*

20. *Gold lacquer chest. Fujiwara period. Kongobuji Temple, Mt. Koya.*

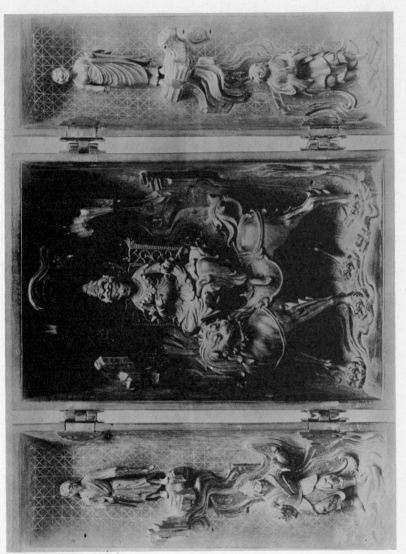

21. *Monju Bosatsu and Attendants, inside of folding pillow. Wood. Late Fujiwara or early Kamakura period. Hojoin Temple, Mt. Koya.*

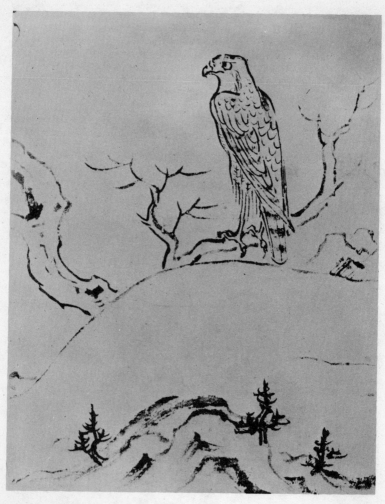

22. *Falcon (detail), by Toba Sōjō (1053–1140). Ink on paper. Late Fujiwara period. Kōzanji collection, Kyoto.*

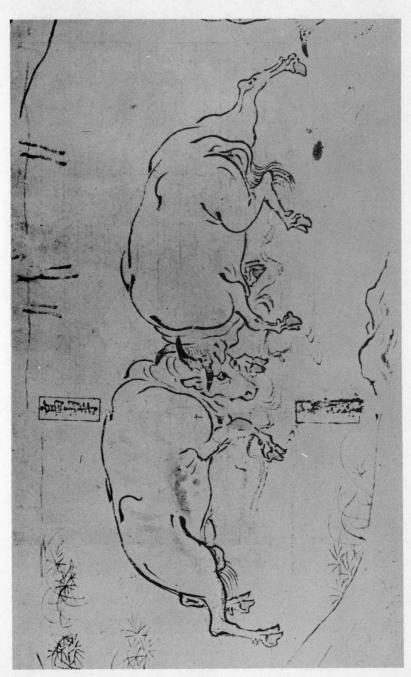

23. *Charging Bulls (detail), by Toba Sōjō (1053–1140). Ink on paper. Late Fujiwara period. Kōzanji collection, Kyoto.*

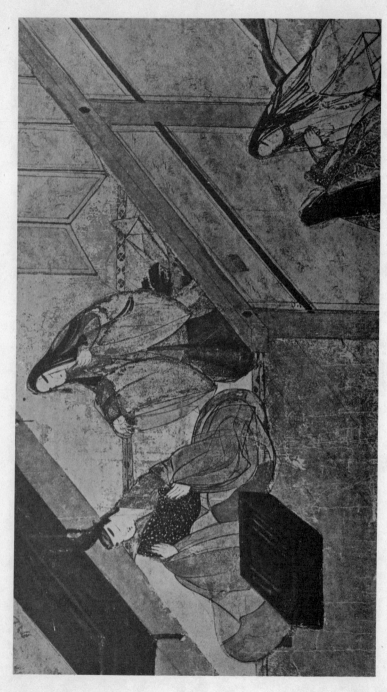

24. *Illustration for the Tale of Genji, attributed to Takayoshi. Full color on paper. Fujiwara period. Baron Masuda collection.*

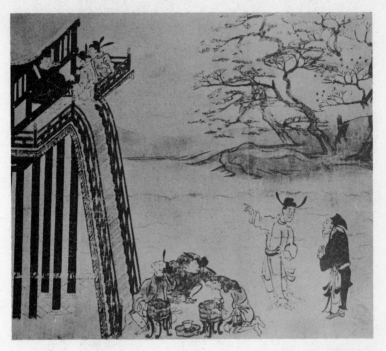

25. *Imprisonment of the Japanese Ambassador at the Chinese Court (detail),
attributed to Mitsunaga. Color on paper. Kamakura period. Museum of
Fine Arts, Boston.*

26. *Divine Messenger in Cloak of Swords Speeding to Cure the Emperor, from the Shigi San Engi scroll, attributed to Toba Sōjō. Light color on paper. Late Fujiwara period. Chōgosbōchiji Temple, Nara.*

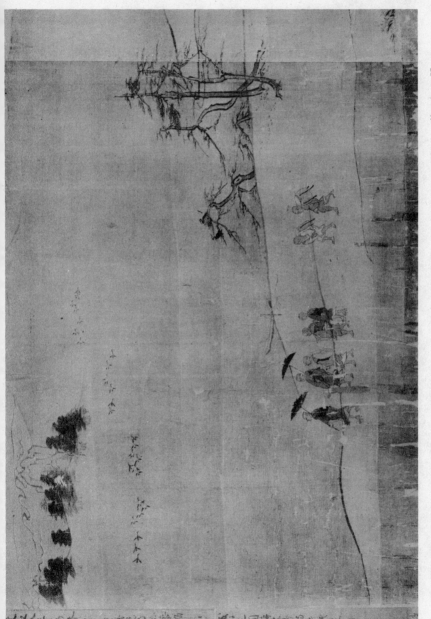

27. *Travels of Ippen Shōnin (detail), by Eni. Color on silk. Kamakura period. Kwangikōji collection, Kyoto.*

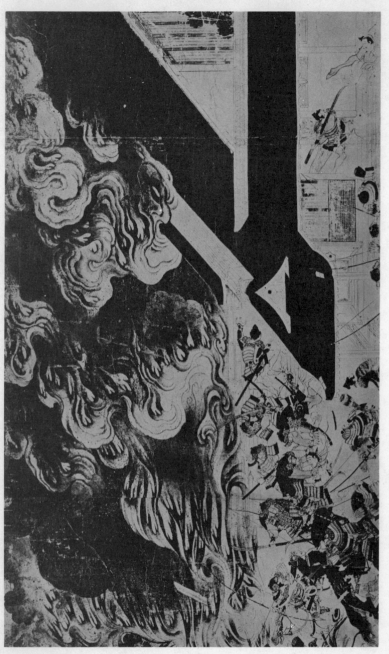

28. *Burning of the Sanjō Palace, from the Heiji Monogatari scroll, attributed to Sumiyoshi Keion. Full color on paper. Kamakura period. Museum of Fine Arts, Boston.*

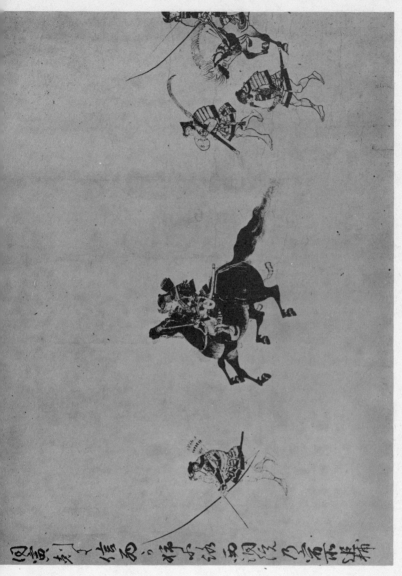

29. Detail from the Heiji Monogatari scroll, attributed to Sumiyoshi Keion. Full color on paper. Kamakura period. Museum of Fine Arts, Boston.

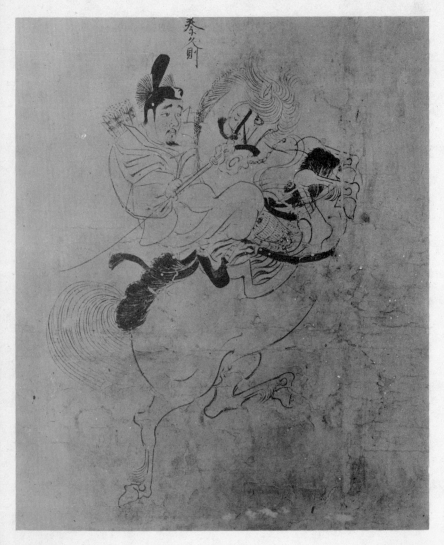

30. *Imperial Guardsman, from the Zuishin-Teiki scroll, by Sujiwara Tamaie (d. 1275). Ink on paper. Kamakura period. Baron Ōkura collection.*

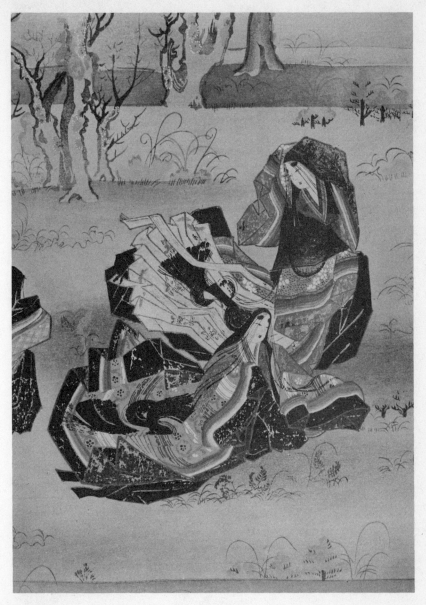

*31. Ladies on a picnic at Sagano, from the Sumiyoshi Monogatari scroll. Full color on paper. Late Kamakura period. Japanese collection.*

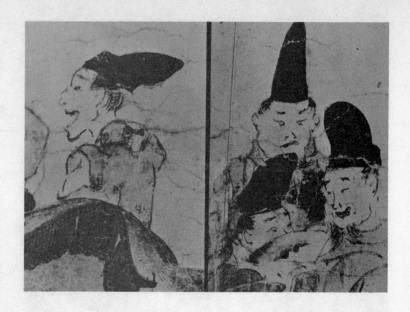

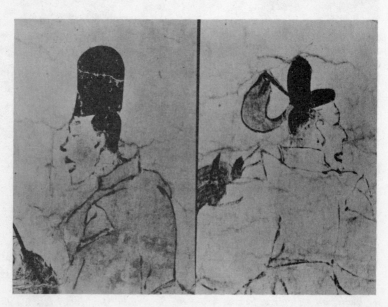

32–35. Details from Ban Dainagon scroll, attributed to Mitsunaga, showing emphasis and variety of facial expression. Kamakura period. Count Sakai collection, Tokyo.

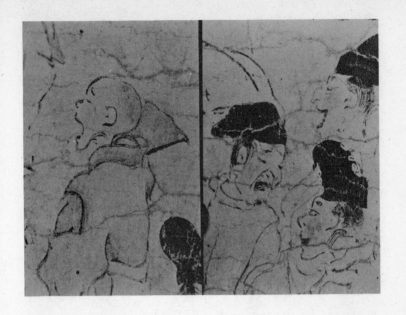

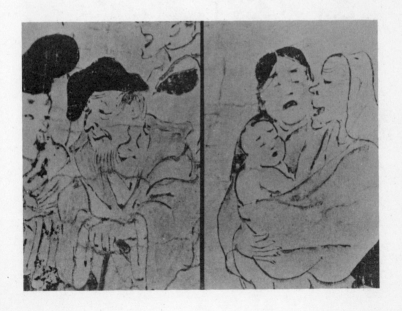

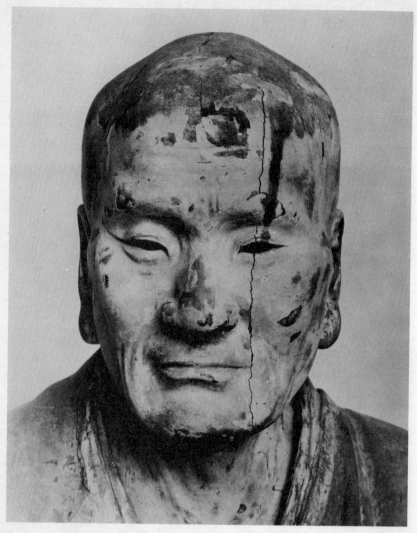

36. *Muchaku Bosatsu (detail), attributed to Unkei. Wood, polychrome. Kamakura period. Kōfukuji collection, Nara.*

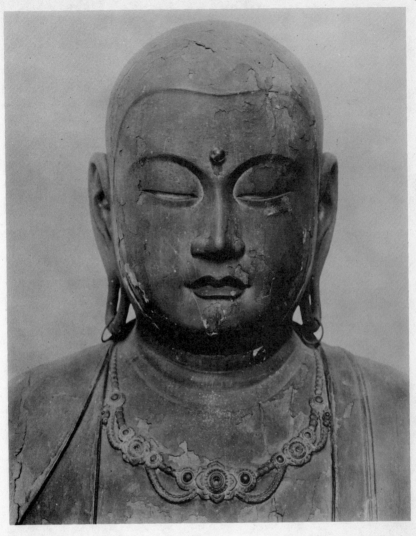

37. *Jizō (detail). Wood, polychrome. Kamakura period. Rokuhara Mitsuji collection,*
*Kyoto.*

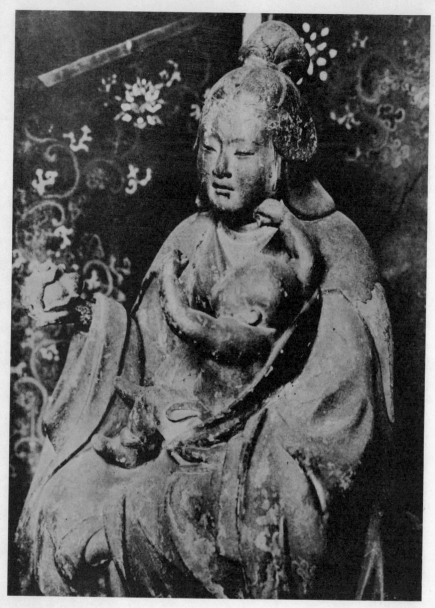

38. *Hariti and Child. Wood, polychrome. Kamakura period. Onjoji collection, Shiga Province.*

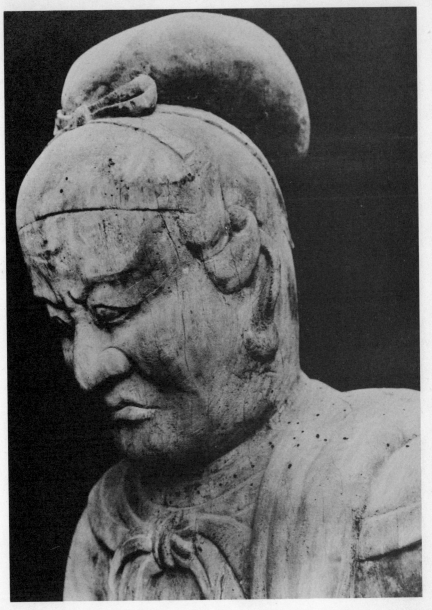

39. *Daikoku Ten (detail). Wood, polychrome. Kamakura period. Kwanzeon-ji Temple.*

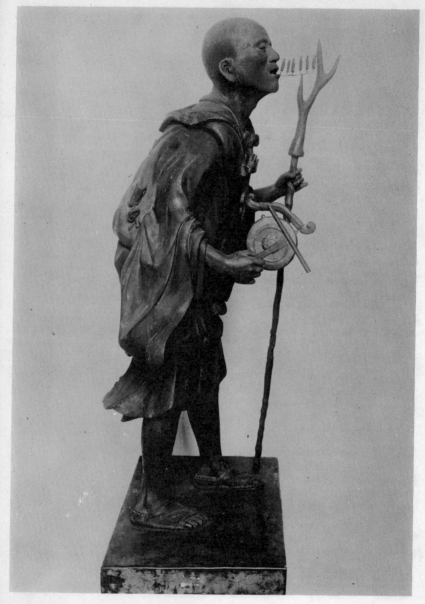

40. *Kūya Shōnin Preaching Amida Doctrines. Wood, polychrome. Kamakura period. Rokuhara Mitsuji collection, Kyoto.*

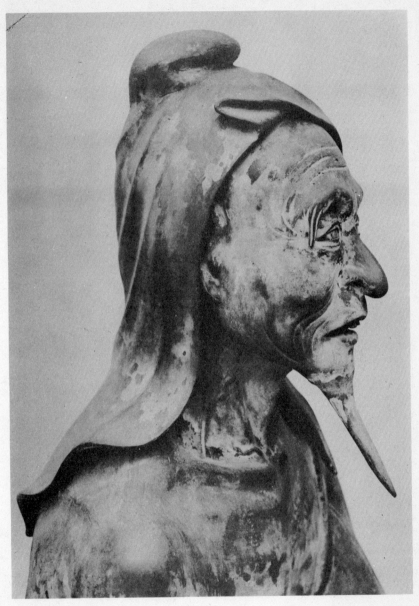

41. *Basu Sennin, Attendant of Kwannon* (detail). *Wood, polychrome. Kamakura period. Sangwatsudō Temple, Tōdaiji Monastery, Nara.*

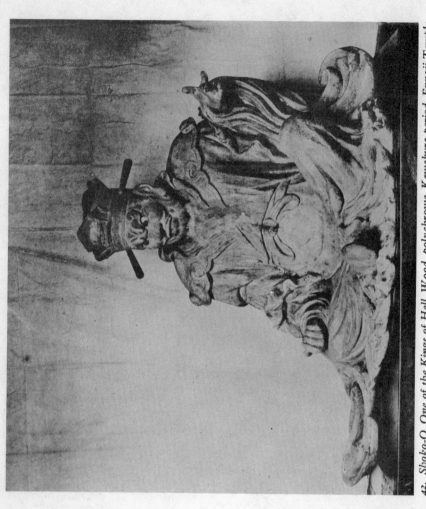

42. *Shoko-O, One of the Kings of Hell. Wood, polychrome. Kamakura period. Emmoji Temple.*

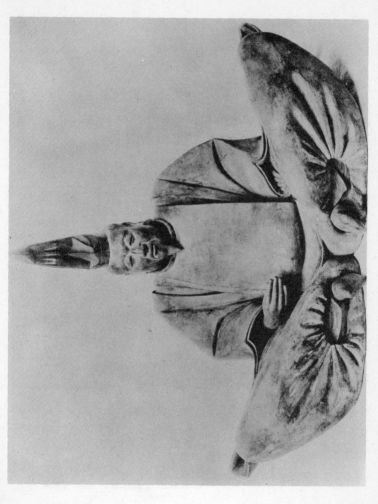

43. *Portrait of Uesugi Shigefusa. Wood, polychrome. Late Kamakura or early Ashikaga period. Meigetsuin Temple, Kamakura.*

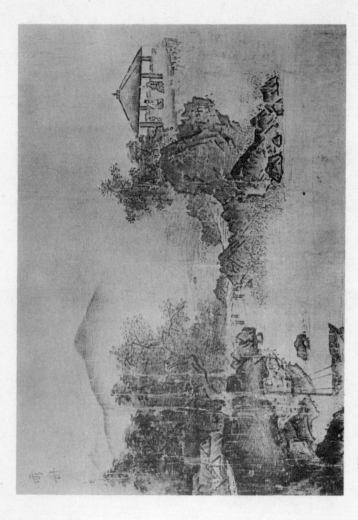

44. *Album landscape, by Sesshū (1420–1506). Ink on paper. Ashikaga period. Marquis Hosokawa collection.*

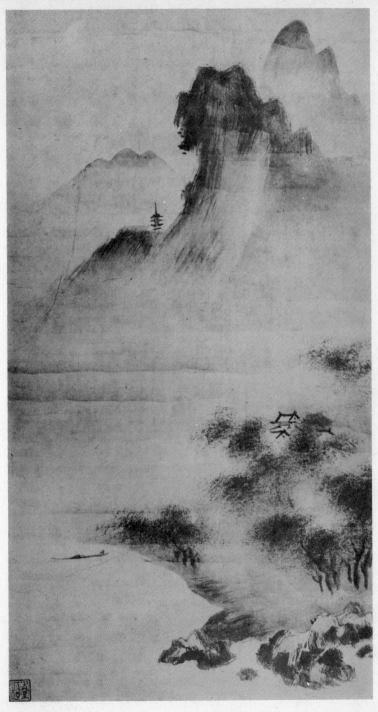

45. *Landscape, by Sesshū (1420–1506). Ink and light color on paper. Ashikaga period. Marquis Kuroda collection.*

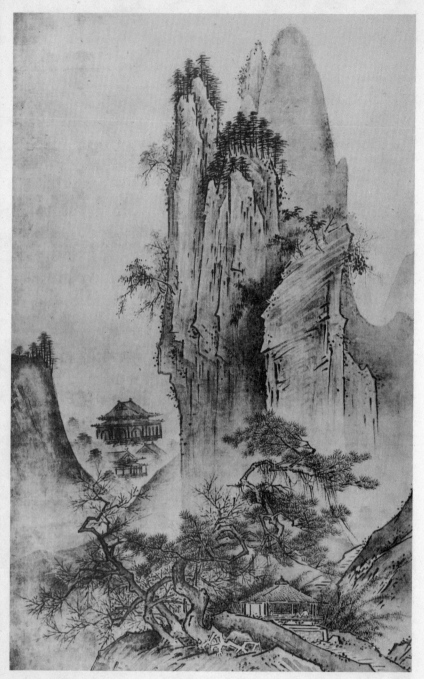

46. *Landscape, by Sesshū (1420–1506). Ink and light color on paper. Ashikaga period. Marquis Kuroda collection.*

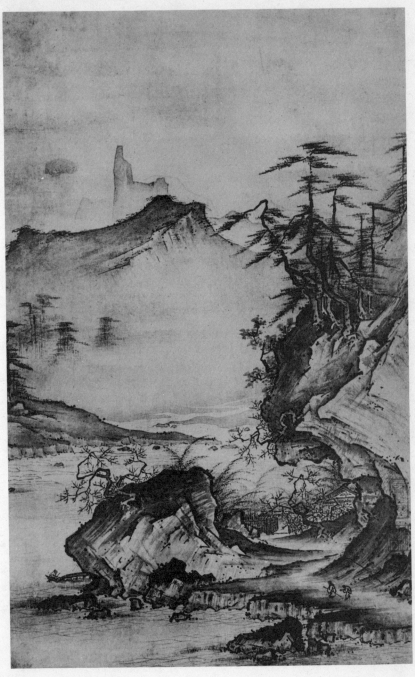

47. *Landscape, by Keishoki (Sesshū school). Ink on paper. Ashikaga period.*
*Kamenosuke Hirose collection, Osaka.*

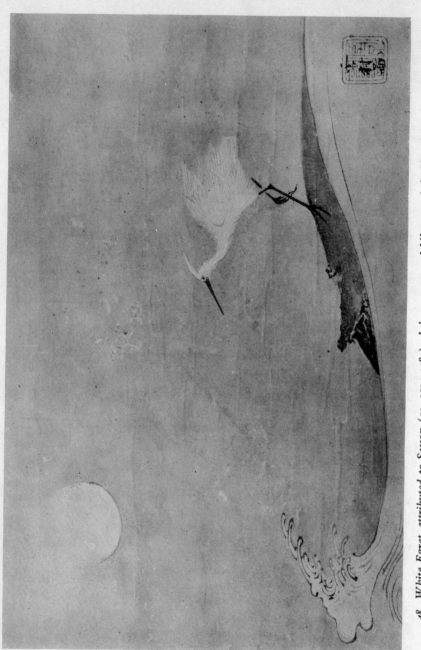

48. *White Egret, attributed to Sesson (ca. 1504–1589). Ink on paper. Ashikaga period. Honolulu Academy of Art.*

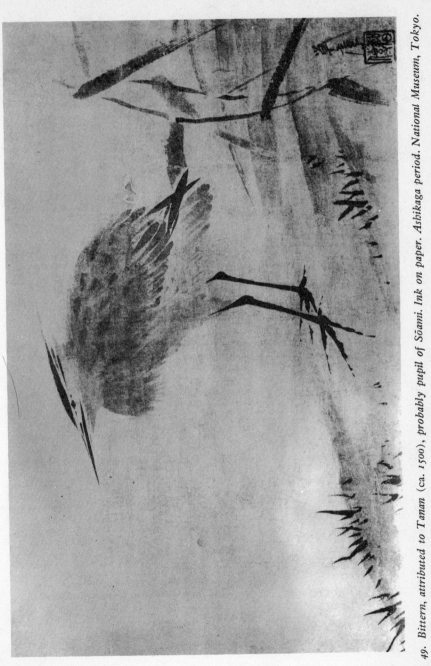

49. *Bittern, attributed to Tanan* (ca. *1500*), *probably pupil of Sōami. Ink on paper. Ashikaga period. National Museum, Tokyo.*

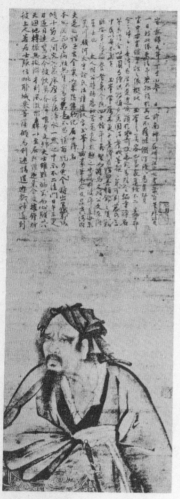

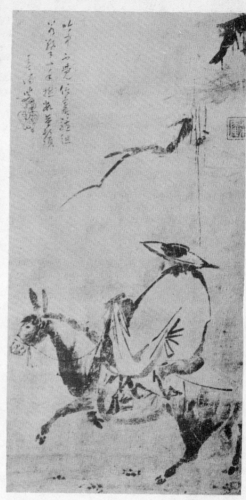

50. *Yuima (Indian sage associated with Zen Buddhism), by Bunsei, a Zen priest. Ink on paper. Fifteenth century. Count Miura collection.*

51. *Eighth-century Chinese poet, Tu Fu, by Sai An. Sixteenth century. Private collection, Japan.*

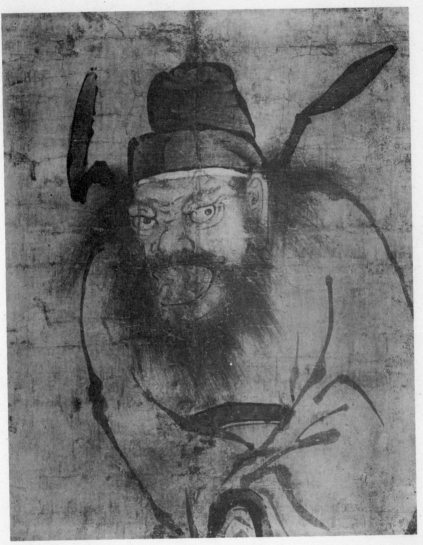

*52. Shoki the Demon Queller (detail), by Dōan (d. 1571). Ashikaga period. Engakuji Temple.*

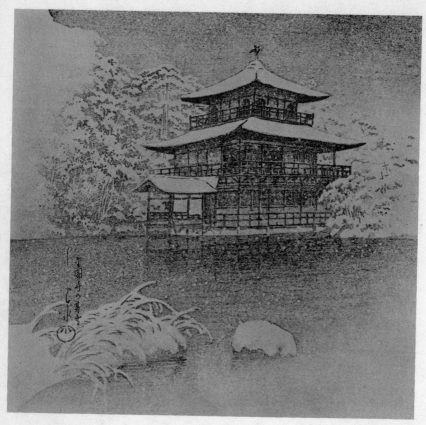

53. *Kinkakuji Pavilion in Snow (built 1397 — burned 1950), from a twentieth-century color print by Hasui (Kawase Bujiro).*

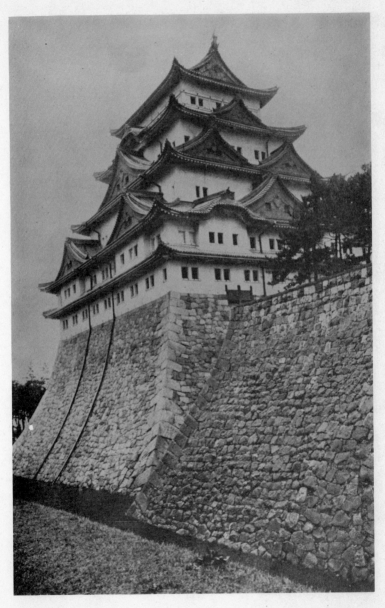

*54. Nagoya Castle, reconstructed in 1610 under the Shōgun Ieyasu.*

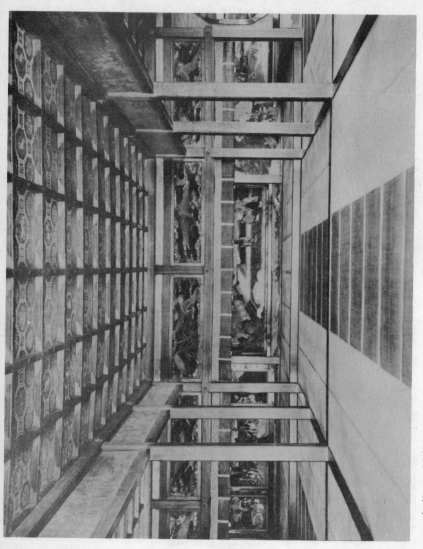

55. *Audience Hall from Momoyama Palace, now at Nishi Hongwanji Temple, Kyōto. Wall decoration by Kano Tanyū and pupils.*

56. *Kara Mon Gate of Daitokuji Temple, formerly part of Hideyoshi's palace (built 1587).*

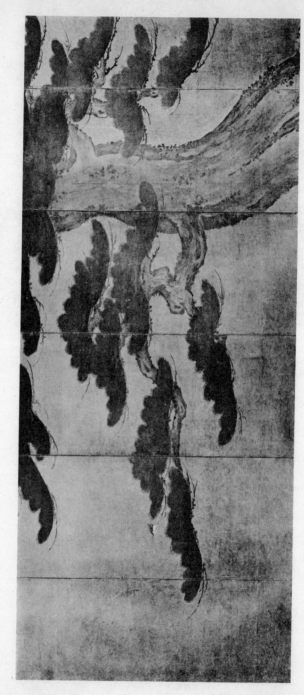

57. *Pine Tree, screen, by Kano Eitoku (1543–1590). Color on gold leaf. Prince Kujo collection.*

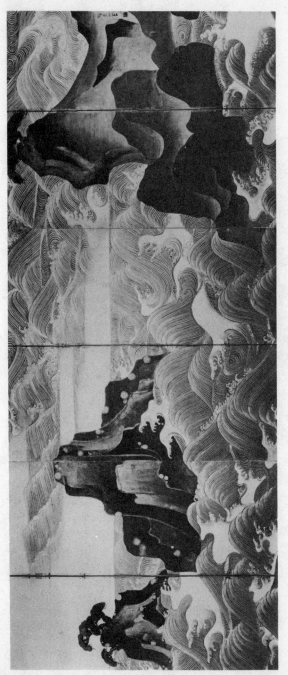

58. *Pine Islands, screen, by Kōrin (1658–1716). Brilliant color on gold leaf. Museum of Fine Arts, Boston.*

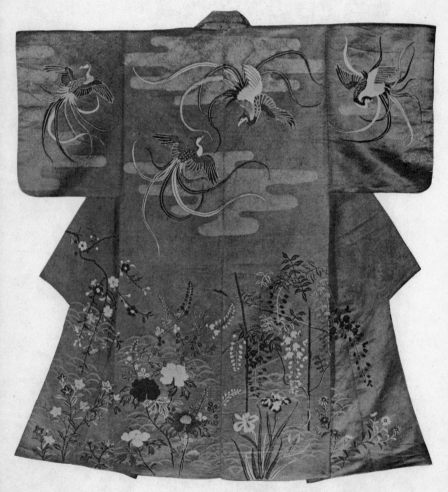

59. *Silk Nō Drama Robe. Embroidered and stencil dyed. Late eighteenth century. Japanese collection.*

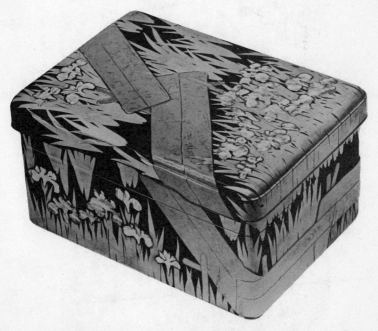

60. *Iris Swamps and Eight-Plank Bridge, lacquer box, by Kōrin (1658–1716). Inlaid with mother-of-pearl and lead. Japanese collection.*

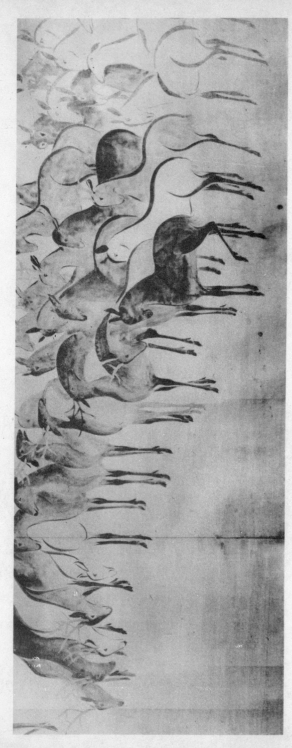

61. *Deer, by Sōtatsu (d. 1643). Ink on paper. Katano collection, Kyoto.*

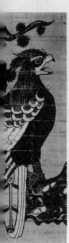

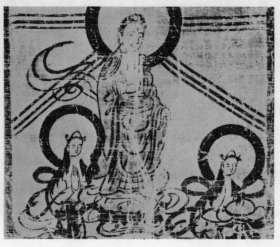

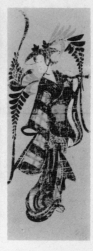

62. Eagle.

63. *Amida Buddha Trinity.*
*Ōtsu paintings. Color on paper.*

64. *Wistaria Maiden.*

65. *Darned cotton socks.*

66. *Darned cotton work kimono.*

67. *Reed snowshoes.*

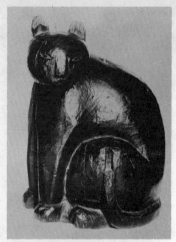

68. *Cat, wood.*

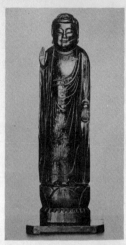

69. *Buddha, wood.*

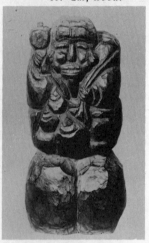

70. *Daikakū, god of wealth, wood.*

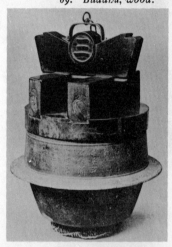

71. *Rice steamer.*

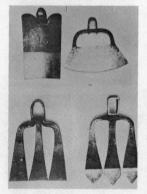

72. *Grub hoes.*

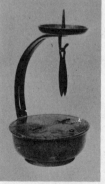

73. *Lamp and pothook.*

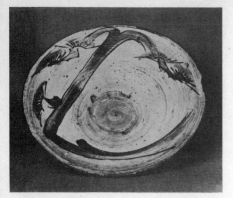

74. *Wash basin, pottery (diam. 2½′).*

75. *Oil plate, pottery (willow).*

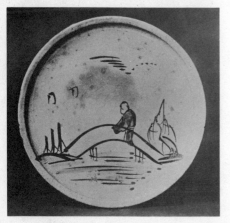

76. *Oil plate, pottery (bridge).*

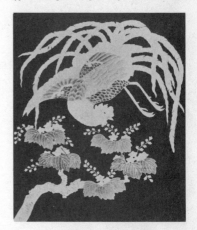

77. *Stencil for textile.*

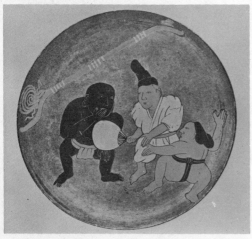

78. *Plate, lacquer (wrestlers).*

79. *Roof tiles, stone.*

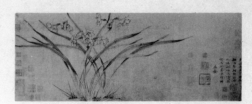

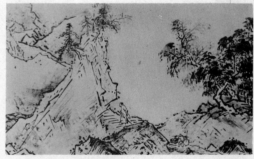

*80–85. Drawings illustrating brush strokes (right column) and corresponding photographs from nature.*

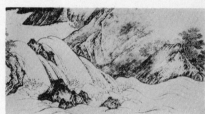

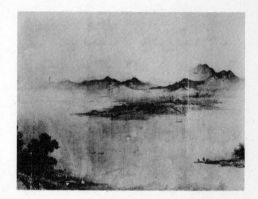

*86–91. Drawings illustrating brush strokes (right column) and corresponding photographs from nature.*

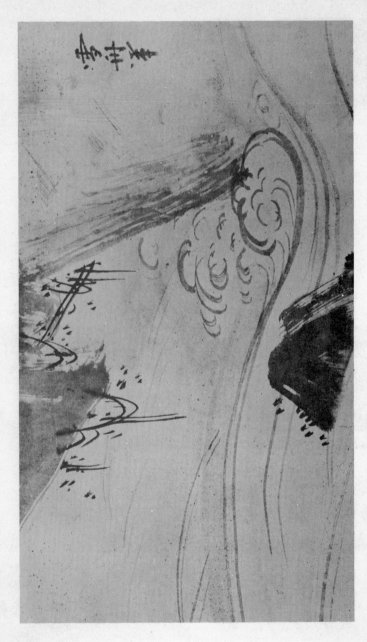

92. *Waves Against Rocks, illustrating flux and stability, by Sesshū (1420–1506). Ink on paper. Zen Buddhist school. Nedzū collection, Tokyo.*